JOSEPH A. GRABAS

OWNING
NEW JERSEY

*Historic Tales of War, Property
Disputes & the Pursuit
of Happiness*

THE
History
PRESS

Published by The History Press
Charleston, SC 29403
www.historypress.net

Back cover, bottom: Mahlon Runyon Farm as depicted on an 1876 Everts and Stewart map of Middlesex County. *Author's collection.*
Back cover, lower inset: Photo of Dr. James Still that appeared in his 1877 autobiography. *Author's collection.*

First published 2014

Manufactured in the United States

ISBN 978.1.62619.620.9

Library of Congress CIP data applied for.

This book is dedicated to my father, who taught me to embrace the lessons of history, and my mother, who gave me the courage to persevere.

CONTENTS

FOREWORD

In *Owning New Jersey*, Joe Grabas turns the title searcher's eye to New Jersey history. His is a unique perspective drawn from years of research in primary documents—deeds, mortgages, leases and assigns—rarely examined by traditional historians. But from these dry, dusty documents, Grabas brings the past to life. He uses a series of case studies, some well known but most revealed here for the first time, to show how landownership has shaped New Jersey's history. We learn of the interactions between early colonists and Native Americans and see how Berkeley and Carteret attempted to profit from the New Jersey business. Joe's thorough research contradicts historical truths when he shows us how Native Americans, blacks and women used legal loopholes to their advantage as they worked to acquire and hold on to real property. Some of his case studies are humorous; others are sad and poignant. Grabas has a storyteller's knack for making the past come to life. *Owning New Jersey* provides a unique and valuable perspective on New Jersey history. I recommend it warmly.

<div align="right">

RICHARD VEIT, PhD
Professor of Anthropology
Monmouth University
Department of History and Anthropology

</div>

PREFACE

As a young boy on his way to becoming an Eagle Scout, I possess vivid memories of earning the various medals that came from hiking with my fellow Scouts through Jockey Hollow and Washington's Crossing. It was easy to love history here in New Jersey—it was everywhere. I remember the day that I road my bike across the Victory Bridge from Sayreville to Perth Amboy just to see what there was to see. How overjoyed I was when I found the grave site of Thomas Mundy Peterson in the St. Peter's Church graveyard. I thought that I had personally discovered the first African American to vote under the Fifteenth Amendment. I was smitten by wanderlust, and I follow her still to this day.

I came to title searching as all of us in it do—by accident. No one grows up wanting to be a title searcher. I had no idea that such a thing even existed before my first visit to the Middlesex County Record Room, or that it would immerse me into coexistence with millions of historical primary source documents each and every day for the vast majority of my life.

At first, it does not present itself that way. Each day, a title searcher is handed multiple title search requests that have to be completed quickly and competently—the end result being that a landowner will be able to sell, lease or refinance a particular parcel of land. (We title searchers think in terms of land, not homes.) There are deadlines that have to be met to maintain the orderly financing and transfer of titles, which is one of the foundations of our economy and society. Not a lot of time to daydream about who the people were or why they were buying or selling this land. Yet over time, for

some of us, the curiosity of land titles begins to take hold, and a realization sets in that these deeds, mortgages and other documents tell a much larger tale. We begin to understand that "deed" is not just a noun, a piece of paper with legal scribbling, but that it is also a verb—the deliberate act of selling or buying land, of mortgaging property to access the intrinsic value of that land so that further endeavors might be achieved.

The most important skills in title searching are observation and analysis. We review each document with a sharp eye, covering the "four corners" for the purpose of revealing matters that might adversely affect or benefit the title. Title to land is different than the land itself. It is the history of that land and its ownership. Unlike other historical research, the purpose is not to discover one particular document that reveals some groundbreaking information about a person, place or event but to identify and compile a chain of documents that effectively chronicles the "life" of a specific parcel of land. In many ways, it is more akin to genealogical research because each parcel of land is derived from a larger parcel and so on, similar to a family tree.

My experience is that land records have been an underused source for historical research. There are so many ways in which these documents can enhance our knowledge of the past—whether they are examined individually or as a group or set of transactions that can reveal certain patterns of commerce, migration, geographic and social dominance, finances and familial ties. I am constantly presented with opportunities to explore the personal histories of our New Jersey ancestors, learning how each of their lives impacted our broader history. It has been said that history is often about presidents, generals and dictators and wars, conquest and religion, but it is the deeds of the ordinary people that truly shape our history and our future. I came to this vocation by chance. It has allowed me to ruminate in the past while charting an interesting and captivating future.

ACKNOWLEDGEMENTS

Where does one begin when commencing the arduous task of thanking all those people who have assisted and supported an effort such as this, and where does one ever end? It is a Gordian task, but I will do my best. First, I thank Randy Gabrielan, a prolific writer and an inspiration. Thanks also to my good friend the Honorable M. Claire French, Monmouth County clerk, who maintains the finest land records program in the state along with the finest county archives, where Gary Saretzky, Tara Christiansen and the rest of the staff are so gracious and helpful; Joe Klett, Bette Epstein and all the staff who vigilantly maintain and guard New Jersey's most precious history at the New Jersey Archives in Trenton; Nancy Conod of the Minisink Valley Historical Society for her time, patience and research on the New York–New Jersey Line War (it didn't make it into this book—maybe the next—but that didn't make her contribution any less important); the Goshen Public Library; the Port Jervis Library; Alicia Batko, the Montague Historical Society; Bill Graff of the New Jersey Geological Survey Office and the good people of the mountain region on both sides of the state line who extended a helping hand and kind advice; Heather Garside; the Passaic County Historical Society; the Lambert Castle Museum and Billy Neumann for his fine photographic work and words of advice to a novice author; Caryn McCann, who welcomed me into her historic home and allowed me to root around its nether regions; Amy Holder from RedVision, who has always been in my corner; Peggy Norris, Ridgewood Public Library, who maintains an extraordinary map collection that is available for everyone;

the Historical Society of Ocean Grove and Ted Bell, its resident scholar, for sharing his wisdom; the title search staff at Signature Information Solutions (another group that will have to wait for future works to see the fruits of their research), many of whom are former employees and students of mine, most particularly Malinda Clickner and my good friend and colleague Mary Ellen Segal, one of the finest land title researchers in New Jersey; Edward C. Eastman Jr., Esq., who shares the same love of land title history and maps as I do; Larry Fineberg, Esq., for having written "The Book"; Danny May, who kept beseeching me with "You really need to write a book"; and my friend and mentor, Dr. Richard F. Veit, who reinvigorated my passion for history as a returning adult college student and is a constant source of inspiration. I have to especially thank the employees and staff at Investors Title Agency—John Tenneson, Barbara Negola, Erin Shinkunas and, most particularly, Heather Paich—for being so stalwart and dependable throughout the process and for their loyalty throughout the years. They are an extension of my family, for whom I have the greatest affection. Heather was my primary personal editor and knows more about punctuation and grammar than I ever forgot in school. Additionally, her skills as a photographer are matchless; I dragged her all over the state so that this book could find life through her keen eye. Thanks also to Whitney Landis and The History Press for taking a chance on a guy who loves history and my parents, who brought me up right. Finally, I must thank my family, who has never wavered in supporting my quest and who spent long hours listening to me pontificate and wax passionately about the most obscure historical tidbits. To my wife, Patti, who I love dearly; my son, Joe, and daughter, Brielle, who make me proud every day; and to all those whose names don't appear above but have contributed to this book and my life, I thank you all so very much. You have helped me realize a dream.

INTRODUCTION

The famed humorist Mark Twain once said, "Buy land, they're not making it anymore." In this simple statement, the genius of Mr. Twain has encapsulated the essence of this book and given us all a chuckle, for it is land that has remained the most consistently valuable commodity in history. Wars have been fought over it; people have abandoned their homeland and traveled across treacherous oceans for it; venerable justices of lofty courts have deliberated over it; legislatures and parliaments have given and taken it; and it has been subdivided, flooded, drained, sold, bought, leased, licensed, mortgaged homesteaded and squatted upon. Land is the essence of life and society.

Long before paper money was backed by gold and silver in New Jersey, it was supported by land bank mortgages. In order to vote, you had to own land. In order to hold public office, you had to own land. Landownership was the pathway to wealth, power and influence in New Jersey. It provided sustenance and a sense of place. Human beings just naturally attach themselves to it, becoming a part of the land and identifying themselves as Jerseyans or Sayrevillians, hailing from Elizabeth or Camden. Down to the block, to the corner and to the stoop, each person plots out his own parcel of land to which he is forever connected. During most of the first two centuries in New Jersey, anyone who did not own real property faced an overwhelming obstacle in his pursuit of happiness.

Maybe that is why it is called *real* estate. The value of land and landownership cannot be understated. I discovered that in 1978, when I walked into the Middlesex County Record Room for the very first time and

stood among millions of pages of land title documents, each and every one affecting a parcel of land—a plot etched out on the face of the globe to which a variety of people throughout our history laid claim, giving succor to each of their lives. Whether it was John Ogden traveling up the Elizabeth River from the east end of Long Island in 1664 or Sabatina Verniello arriving in Port Reading in 1917 to buy a simple house that would be home to four generations of Italian Americans, each deed, mortgage, lis pendens, building contract, federal lien and filed map tells a story. All part of the bigger story of New Jersey.

Land documents are similar to mileposts on a highway, letting you know where you are at that exact moment in time but not telling where you have been or where you are going. Deeds mark those instants also, yet now and again, they provide hints of the bigger narrative. Every document has an untold tale that begins well before the date of the deed and continues long afterward. It begins with the desire to own land and the recognition of its true value and continues in the search for the right land, getting the money to purchase it, the negotiations leading to the final deal and then mortgaging the property. Once the title is transferred, the debt has to be paid back over time, sometimes with great success and other times ending in bankruptcy or foreclosure. At times, the land is subdivided, and new stories begin for many other people. Yet there are instances in which the land is barren, the sheriff pays a visit and the dream ends. But the land endures. When taken together and connected into a *chain of title*, these documents repeatedly offer insight into the lives of the ordinary and extraordinary people who have collectively written our history.

Over nearly four decades of rummaging through land titles in dusty vaults and foul-smelling basements, I have found that the land records are a largely untapped well of historical information that can reveal the most interesting and unexpected revelations. As I wandered through those records, I found myself thumbing through the pages of their lives. I discovered people like John Glenn, who struggled to realize the dream of owning his own grocery in Trenton; silk baron Catholina Lambert, who lived in a grand castle on the hill, only to see his life crumble around him; John Lydecker, whose despair was forever chiseled on his forgotten gravestone buried in a yard in Leonia; and the Lenape Sachem Iraseeke, who was far more clever than the settlers gave him credit for. The land records reveal the hierarchy within communities, the interaction between dominant families and factions and the struggle to rise up through society and acquire a seat at the table of leadership.

The history of New Jersey is underpinned by landownership. Unlike many other colonies, most of the earliest settlers did not come across the sea directly to New Jersey to escape religious persecution and social injustice. They generally came from New England and other colonies to the Garden State. Why? Land. This was some of the finest land in North America, and the proprietors of New Cesarea were eager to sell. New Jersey provided endless opportunities. Located at the center of the English dominions in North America, it would quickly become the crossroads of colonial commerce, bookended by two major cities, and later the primary theater of the War for Independence. Surrounded on three sides by water with a vast network of navigable rivers and streams, each settler was placed within manageable proximity to the primary transportation system. Fertile soils of the glacial drift, left behind at the terminal moraine and the abundance of wetlands without the threat of malaria, invited settlers to purchase large swathes of land and, in turn, sell portions to others looking for a place of their own. Land speculation was the engine that drove the settlement and development of the Jerseys.

So it is fitting that the birth certificate of New Jersey is not some grand royal charter or the result of a bloody battle but rather a simple *Deed of Indenture*, dated June 24, 1664. The purpose of this book is to expand the discussion about the importance of land and landownership to the development of New Jersey and its people in a way that opens the mind and excites the imagination.

NEW JERSEY'S BIRTH CERTIFICATE: THE ORIGINAL 1664 DEED

For such as pretend to a right of propriety to land and government, within our Province, by virtue of any patent from Governor Colonel Richard Nichols, as they ignorantly assert, we utterly disown any such thing.
—J. Berkeley and G. Carteret, December 6, 1672

As he stood on the quarterdeck of a British frigate, surging across the vast ocean sea, Colonel Richard Nicolls was confident in his mission to expand the royal dominions and unite the colonies in America by expurgating the Dutch from New Netherland. Nicolls was undoubtedly aware that this was a significant and historic undertaking, for which he would be handsomely rewarded with lands, honors and treasures if he were successful. What lay ahead was a Dutch fort and valuable commercial port that stood between and divided the New England colonies and the Virginia colonies. It was the key to dominance of the North American coast.

What he could not have possibly known was that, rather than soldiers and sailors and warring nations, he was sailing directly into a much greater and far more desperate conflagration involving land titles and property rights. Colonel Nicolls was firmly ensconced in his mission and held the Duke's royal grant from King Charles II, dated March 12, 1664, in one hand and the Duke's explicit instructions to capture, conquer and settle all the lands between the Connecticut and Delaware Rivers in the other. The English had already made settlements in Massachusetts, Rhode Island, parts of Connecticut, Long Island and all the islands in the Sound, Jamestown, up the Chesapeake and along the

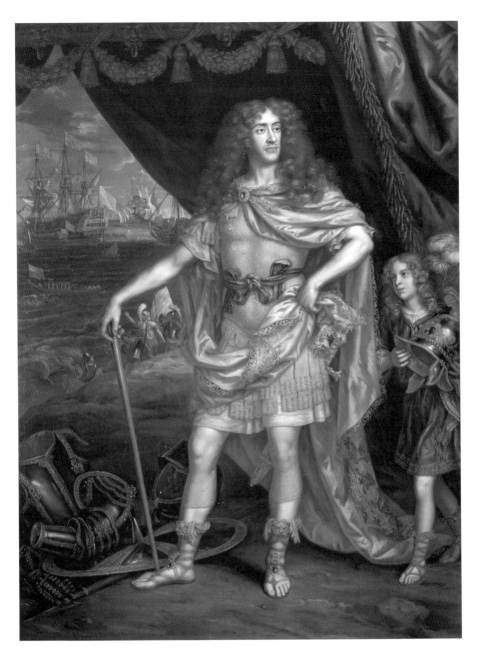

James, Duke of York, brother of King Charles II and future king of England. *Wikimedia Commons*.

eastern shore. In between sat New Netherland, held by the Dutch as one part of a worldwide system of commerce and trade, allowing Dutch merchants to dominate the globe. The English recognized the threat and wanted what the Dutch had enjoyed for so many years. Yet subduing the Dutch was arguably the simplest part of Nicolls's task. Those documents, his actions and certain events over the next few years would lead to armed insurrection, land riots and protracted litigation that would never officially conclude. It was 1664, and the Wild West began at the New Jersey shoreline.

The Dutch Period

There had been many European visitors to the Jersey shores prior to 1664—Cabot, Verrazano and, most famously, Hudson, to name a few. Robert Juet, who served aboard the *Half Moon* under Hudson, described in his journal a wondrous Eden teeming with flora and fauna: "The Lands…were as pleasant with Grasse and Flowers, and goodly Trees, as ever they had seen, and very sweet smells came from them."[1] Johannes De Laet, a seventeenth-century author with ties to the Dutch West India Company, wrote a series of books on the New World in which he noted, "I am…of the opinion that scarcely any part of America is better adapted for the settlement of colonies from our country, especially since nothing is wanting that is necessary to sustain life and the soil can be rendered still more productive by labor and industry."[2] With high praise such as this, one would have expected a flood of settlers to New Netherland. Yet despite the arrival of the Dutch in 1624, no settlement resulting in an expanded permanent population and development would occur until the English arrived in 1664. This incongruence can be directly attributed to the limitations of the Dutch system of land ownership versus the English system and the mercantile nature of the Dutch occupation.

New Netherland was an expedition underwritten first by the Dutch East India Company, which sent Hudson; then the United Netherlands Company, which sent Mey and Block; and finally the newly formed Dutch West India Company (1621), which sent Peter Minuet to establish a permanent trading base and negotiate with the Indians. These were all mercantile and commercial ventures for the specific purpose of expanding the control of global trade for the Dutch during what was generally recognized as their "heroic" period.[3] The Netherlands enjoyed the largest commercial navy in the

world and needed strategically located strongholds with deepwater-protected harbors to maintain its dominance. The harbor at the mouth of the North River (later Hudson River) was perfectly situated, large enough and deep enough to accommodate the sailing ships of the time, protected by Staten Island and Sandy Hook and located at the confluence of the Hudson, Passaic, Hackensack, Raritan and Shrewsbury Rivers, which provided a vast network of navigable highways to bring natural resources, trade goods and commerce all to a central port. Finally, and most importantly, it was surrounded by some of the finest, most accessible land in the North American colonies, with a temperate climate where the harbor would rarely freeze over. The nature of this land would nourish commerce. So it was the aim of the Dutch West India Company to establish trade, chiefly in furs and timber, along the North River, the longest navigable watercourse into the interior of New Netherland. Their model or system for accomplishing this was the establishment of two forts/trading centers located at the tip of Manhattan Island in the harbor and upstream at the present site of Albany, New York, known respectively at the time as Nieuw Amsterdam and Fort Orange.

This venture was a business, and the vast majority of the Dutch "settlers" were, in fact, employees. They signed on for a period of years to work and profit for the Dutch West India Company. They could not establish separate trade with the natives; they worked strictly for the company. This was not a grand social experiment in religious tolerance or an escape from persecution, such as the Pilgrims or Puritans of New England. This began as a mercenary endeavor operated through contract labor and not for the promise of some better existence through self-determination with access to vast tracts of land held in fee simple ownership, where a person could establish a home, a family and a future. This would necessarily change over time as the attitudes and desires of the employees were awakened, making the advent of the English system that much more appealing.

The main objective for the Dutch West India Company was to harvest as many furs (specifically beaver) as possible and send them back to Europe for, of all things, fashion. It was not so much the outer fur of the beaver that was coveted but the inner pelt, which was processed to make felt for hats. These were the black, wide-brim hats of the era most commonly recognized as worn by the Pilgrims or the Dutch Masters. The inner pelts were treated with a heated solution of mercuric nitrate through a process called carroting, which separated the felt from the pelt. It was the noxious fumes and exposure to mercury given off through this process that would give birth to the term "mad as a hatter." The mercury exposure would attack the nervous system

and cause irreparable brain damage.[4] Whether it be wigs, corsets, hoop skirts, high heels or hats, human society has always been a slave to fashion, despite its nefarious consequences.

Under the Dutch, large tracts of land were distributed through the patroon system. This entailed huge parcels of the choicest land conveyed in the form of Manorial Estates, many of which were owned by absentee landowners who brought individual workers over to work the land through a series of indentures and tenancies, once again as employees, not landed settlers. This system very much mimicked the ancient European model of manors and fiefdoms, exclusive to the nobility. These patroonships discouraged long-term settlement by emigrants seeking self-determination, self-sufficiency and, ultimately, self-rule. The most famous of these was Rensselaerswijck, a vast area of upstate New York that straddled the Hudson River and surrounding Fort Orange (Albany) that was granted to Kiliaen van Rensselaer in 1630. The fee title to this land remained in the van Rensselaer family for over two hundred years while it was settled, developed and worked by tenant farmers. It was not until after continuous litigation that the feudal patroonship was finally broken and the tenant owners were able to finally acquire the fee title. Nevertheless, the Dutch had no significant success in settling the west side of the North River (Hudson) across from Nieuw Amsterdam, an obvious site for colonial expansion.

In 1630, a patroonship was granted to Michael Pauw, one of the directors of the Dutch West India Company. This tract, located in present-day Jersey City, would be the first attempt at settlement in Jersey and was called Pavonia. Unable to populate it with fifty settlers, Pauw soon sold the land back to the company in 1635.[5] The 1639 Vinckeboons map shows eight structures on the western shore, although the settlements were small and relations with the indigenous population marred by intermittent conflict. These disagreements with the Native Americans led to armed conflicts such as the Pig War (1641), the Whiskey War (1642), Kieft's War (1643), the Peach Tree War (1655) and the Esopus War (1658). One of the failings of the Dutch was their inability to live peacefully with the Lenape. The Dutch were quick to react violently when marginally provoked. Nothing could be more poignant and painful than the eyewitness account of the Dutch attack on the natives that would become known as the Pavonia Massacre. David Pieterz de Vries, a resident of Nieuw Amsterdam, recounted the horrors of the engagement on the night of February 25, 1643:

> *When it was day the soldiers returned to the fort, having massacred or murdered eighty Indians...in their sleep; where infants were torn from their*

*mother's breasts, and hacked to pieces in the presence of the parents, and the
pieces thrown into the fire and in the water, and other sucklings, being bound
to small boards, were cut, stuck, and pierced, and miserably massacred in a
manner to move a heart of stone.*[6]

The failed relationship between the Dutch and Lenape would be an important lesson for the English, who would seize power in the next few decades. They would adjust their future deportment in a manner that would effect good relations with the native inhabitants of Jersey. Moreover, it would provide the key to successfully disenfranchising the Lenape of all their property rights in the future.

The Dutch West India Company would prosper and expand slightly through 1664. Manors and lands would be granted on the east side of the North River to men such as Adriaen Van Der Donck (Yonkers) and Jonas Bronck (The Bronx) and on the west side in places like Harsimus, Hobocan, Communipaw, Raccocas, Pembrepogh and Bergen to men such as Pauw, Lubbertse, Van Schalckwyck, Gerritsen, Varlet, Pieterse and Bayard. It appears that Peter Stuyvesant embarked on a concerted program of land transfers for property on the western shore just prior to the English conquest.[7] Beginning in 1654 and running up to the early months of 1664, Stuyvesant conveyed dozens of land grants in the area from Hoboken south to present-day Bayonne. Was Stuyvesant prescient of the impending conquest and acting to settle as much land as possible, or was he simply furthering the interests of the Dutch West India Company by expanding its settlements? Despite this expansion, and due to the continuing conflicts with the natives, the business of New Netherland remained south of the wall on the very tip of Manhattan Island, at the center of commerce. It was there on August 19, 1664, that Sir Robert Carre and Colonel Richard Nicolls would arrive with a squadron of four British frigates and serve terms upon Governor Peter Stuyvesant.

After numerous and various correspondence between Nicolls and Peter Stuyvesant, the Dutch colony was surrendered and renamed New York. Nicolls, as deputy governor, was given the power to convey and confirm all lands along with the power of governance.[8] A most important land title document was the result of the negotiations between Nicolls and Stuyvesant, the *Articles of Capitulation on the Reduction of New Netherland*, effective September 8, 1664. This document provided not only that the existing settlers would be allowed to remain in New York but that they would also be granted significant rights, chief among them the right to retain their land titles. Article 3 noted: "All people shall still continue

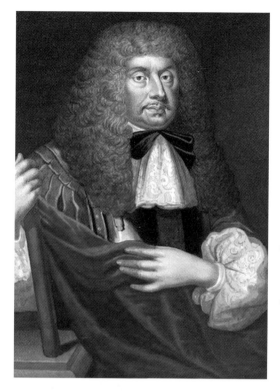

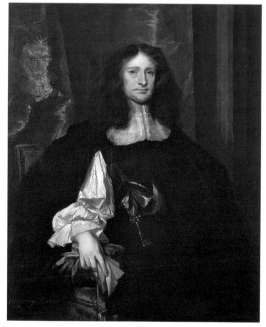

free denizens and enjoy their lands, houses, goods, ships, wheresoever they are within this country, and dispose of them as they please."[9]

This reservation of existing property rights would be at odds with the rights of the actual landowners on the west side of the Hudson River. Unbeknownst to Nicolls, while he was at sea, James Duke of York had conveyed the land soon to be called New Jersey to Lord John Berkeley and Sir George Carteret on June 23–24, 1664, by lease and release, setting into motion a series of land title and boundary disputes that would plague the province and state of New Jersey for centuries.

Top: Lord John Berkeley, baron of Stratton and member of His Majesty's Most Honourable Privy Council. *Wikimedia Commons*.

Left: Sir George Carteret of Saltrum in the county of Devon, knight and member of His Majesty's Most Honourable Privy Council. *Wikimedia Commons*.

The English System

The evolution of fee simple real property ownership in Europe at the time of settlement was still in its relative infancy. Up until the sixteenth century, most land was held by right of conquest, establishing a feudal system (derived from the terms "feoda," "feuds," "fiefs" or "fees," which mean reward) of landownership brought to England by William I and the Norman Conquest in 1066 and the physical ability to maintain same from other interlopers.[10] One lord would exercise authority and dominion over all the land, property and people that existed within his domain; this would include police powers and the holding of manorial courts. Instead of seeking redress from the king or parliament, the vassals of a particular estate would come before the lord and submit their cause of action to him for settlement and rendering of decision.

The feudal system supposed that all realty was primarily possessed of the sovereign, who would then grant certain rights or tenements to lesser noblemen, who would then, in turn, divide such land among other nobles subservient to them. The glue that held this system together was the feudal service, which each of these tenants owed to their superior landlord, thus forming a pyramid of indebtedness with the king at the top. The original intent of this network of service was the ability to raise an army to defend the estate or nation at minimal expense and in a limited time. But there were other types of service and incidents reserved to the overlord, including knight service, *frankalmoin* service and socage, escheat, aids, relief, wardship and marriage.[11] The lords retained the right to reach into almost every phase of their subjects' lives with the idea that those who possess land possess power. This system was the specific domain of aristocracy and "not merely a scheme of land ownership; it was also a moral, ethical and social system which defined the relationship among different classes in Medieval English Society."[12]

In 1485, when King Henry VII began to establish England as a nation under one supreme sovereign, he started to reconsolidate and redistribute land under the name of the king and through the use of the Parliament and the passage of various bills of attainder, wardships and escheat. His son Henry VIII would accumulate even greater amounts when he seized the lands of the church.

It was Henry VIII's redistribution of those lands to non-aristocrats that was to forever change the feudal concept of landownership and move toward an allodial or independent landownership system in England. As early as 1290, the service and duties integral to the feudal system were being challenged

first by the enactment of the *Statute Quia Emptores Terrarum*, which replaced subinfeudation with substitution (thereby setting the precedent for the fee simple estate in land), and later the Statute of Uses (1536), which eliminated the requirement for the ancient and mystical ceremony of livery of seisin for the transfer of land.[13] Livery of seisin was a public ritual before witnesses in which the seller would stand on the ground to be conveyed, picking up sticks, dirt and rocks from that land and placing them in the hands of the buyer while proclaiming the boundaries of the property, along with the terms of payment and the affirmative act of conveyancing.[14] Sometimes invoking the names of saints or past kings, the seller would state, "This turf and twig I give to thee, as free as Astheltan gave to me, and hope a loving brother thou wilt be."[15] The Statute of Wills (1540), which allowed the transfer of real property by will; the Statute of Tenures (1660), which converted most feudal obligations into money or goods; and, finally, the Statute of Frauds (1677), which required the use of written deeds in the conveyance of realty, would all serve as the legal foundation for the land title transfer system in New Jersey. This practice was generally in use since the abolishment of livery of seisin. Many of these ancient statutes can be found codified in New Jersey's current laws.[16]

It is just precedent to the Statute of Frauds that the history of New Jersey as an English colony begins. Charles II, who returned to the throne in 1660, granted a large tract of land in the New World to his brother, James the Duke of York, by Royal Grant on March 12, 1664. James subsequently conveyed what would become the province of New Cesarea or New Jersey to John Lord Berkeley, Baron of Stratton, and Sir George Carteret, of Saltrum in the county of Devon, both members of the king's privy council, by lease and release on June 23–24.[17] Both of these individuals were closely connected to Charles II and James. Governor of Exeter, Berkeley was one of three commanders in the English Civil War serving under Prince Charles (fifteen years old) as he attempted to direct the war effort in the four western counties. Berkeley would later be installed as James's governor while exiled in the Netherlands and France. Although not happy with him at first, James would grow to favor Berkeley, so much so that he stood against his brother Charles II in 1657 on Berkeley's behalf until Charles capitulated, naming Berkeley a baron.

Carteret was equally important to the king and his brother in that he was the governor of the Isle of Jersey, a formidable island fortress just off the coast of France, where Charles fled in exile in April 1646. Charles II was to return to Jersey several times during his exile, always taking full advantage

of his host, George Carteret. On January 30, 1649, George was the first to proclaim Charles II king of England on the Isle of Jersey at St. Helier. While in exile, Charles's prospects seemed very bleak. Only through considerable welfare and charity of royalists like Berkeley and Carteret could he hope to survive. His financial situation was desperate. In 1649, Charles was forced to sell much of his land on the Isle of Jersey and granted a patent to seven individuals, including Berkeley and Carteret, for as yet unappropriated land in North America to secure his indebtedness and the loyalty of these men.[18] It is evident that without landownership, even the power of the king of England was minimal. He engaged individuals who had the faith that he would once again return to the throne in order to collect upon their debts and become seized of the lands promised. Men like Berkeley and Carteret did not follow the exiled boy king for some altruistic love of monarchy. It was their hope that they would continue to profit from the patronage system that had served them so well for generations. Carteret would later be considered one of the wealthiest men in England. Not only did Carteret and Berkeley receive the New Jersey grant of 7,836 square miles (one-sixth the size of England), but they were also among the eight proprietors of the Carolinas (North Carolina, 52,586 square miles; South Carolina, 31,055 square miles). When considered together, Berkeley and Carteret would receive a dominion almost twice the size of England (58,545,280 acres), over which they were granted the right of soil and the right to govern.

The reason for the conveyance and settlement of New Jersey was twofold. First, it would repay loans granted to the king during his exile. Second, and most importantly, it would seize control of the sea from the Dutch. James the Duke of York, now lord high admiral at twenty-seven years old, was determined to establish Britain as the predominant sea power and control the trade routes. He set about forming trading companies consisting of merchants, diplomats, MPs and other royalists, including Berkeley and Carteret. Berkeley was named to the Navy Board in 1660,[19] and Carteret was the treasurer of the Royal Navy.[20] In direct response to expanding Dutch trade influence throughout the world, James created the Royal African Company, the Morocco Company and the Corporation of Royal Fishery.[21] He waged an undeclared war against the Dutch, who had only years before provided safe haven for him and his brother, the exiled king. James had never endeared himself to the Dutch, having run up considerable debt while in the Netherlands and showing contempt for them in general. Quite possibly, it was due to his suppressed Catholicism or simply that he was an impudent boy with too much time on his hands. The Dutch would repay him in kind

when his daughter Mary and her husband, William of Orange, seized King James II's throne in the Glorious Revolution of 1688.

The Duke's Grant

An original copy of the Duke of York's grant to Berkeley and Carteret, over 350 years old, resides at the New Jersey State Archives in a special vault. It bears the signature of the future king of England, signed simply "James." In so many ways, this is the birth certificate of New Jersey. It is the first document to bear the "Name or Names of New Cesarea or New Jersey."[22] It is the first document to contain a description of the new province, a description that would be hotly contested by the neighboring colonies of New York, Pennsylvania and Delaware. And it is the first document to recognize New Jersey as a separate and unique physical and political entity from New Netherland and New York. Therefore, it bears a purpose to set forth the document at length herein, as it will be referenced repeatedly throughout this book.

> *This Indenture made the Fower [four] and twentieth day of June in the Sixteenth year of the Raigne of our Sovereigne Lord Charles the Second by the grace of God of England, Scotland, France and Ireland King defender of the Faith &c Annoq's Domini 1664. Between His Royal Highness, James Duke of York, and Albany, Earl of Ulster, Lord High Admiral of England, and Ireland, Constable of Dover Castle, Lord Warden of the Cinque ports, and Governor of Portsmouth, of the one part: John Lord Berkeley, Baron of Stratton, and one of His Majesty's most Honourable Privy Council, and Sir George Carteret of Saltrum, in the County of Devon, Knight and one of His Majesty's most Honourable Privy Council of the other part: Whereas his said Majesty King Charles the Second, by his Letters Patents under the Great Seal of England, bearing date on or about the twelfth day of March, in the sixteenth year of his said Majesty's reign, did for the consideration therein mentioned, give and grant unto his said Royal Highness James, Duke of York, his heirs and assigns, all that part of the main land of New England, beginning at a certain place called or known by the name of St. Croix next adjoining to New Scotland in America; and from thence extending along the sea*

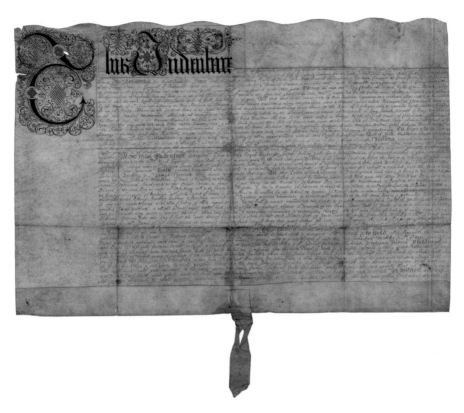

The "birth certificate" of New Jersey, the June 24, 1664 Release from James, Duke of York, to Berkeley and Carteret. *Courtesy of New Jersey State Archives.*

coast unto a certain place called Pemaquie or Pemaquid, and so by the river thereof to the furthest head of the same as it tendeth northward; and extending from thence to the river of Kenebeque, and so upwards by the shortest course to the river Canady northwards; and also all that island or islands commonly called by the several name or names of Matowacks or Long Island, situate and being towards the west of Cape Codd and the Narrow Higansetts, abutting upon the main land between the two rivers there, called or known by the several names of Connecticut, and Hudson's river; together also with the said river called Hudson's river, and all the land from the west side of the Connecticut river to the east side of the Delaware Bay: and also several other islands and lands in said Letters Patents mentioned, together with the rivers, harbours, mynes, mynerals, quarries, woods, marshes, waters, lakes, fishing, hawkings, buntings, and

28

fowling, and all other royalties, profits, commodities and heriditaments to the said several islands lands and premises belonging and appertaining, to have and to hold the said lands, islands, hereditaments and premises, with their and every of their appurtenances, unto his said Royal Highnesse James Duke of Yorke, his heires and assigns for ever; to be holden of his said Majesty, his heires and successors, as of the manor of East Greenwich, in the County of Kent, in free and common soccage, yielding and rendering unto his said Majesty his heirs and successors of and for the same, yearly and every year, forty beaver skins, when they shall be demanded, or within ninety days after; with divers other grants, clauses, provisos, and agreements, in the said recited Letters Patents contain'd, as by the said Letters Patents, relation being thereunto had, it doth and may more plainly and at large appear. Now this Indenture witnesseth, that his said Royal Highness James Duke of York, for and in consideration of a competent sum of good and lawful money of England to his said Royal Highness James Duke of York in hand paid by the said John Lord Berkeley and Sir George Carteret, before the sealing and delivery of these presents, the receipt whereof the said James Duke of York, doth hereby acknowledge, and thereof doth acquit and discharge the said John Lord Berkeley and Sir George Carteret forever by these presents hath granted, bargained, sold, released and confirmed, and by these presents doth grant, bargain, sell, release and confirm unto the said John Lord Berkeley and Sir George Carteret, their heirs and assigns forever, all that tract of land adjacent to New England, and lying and being to the westward of Long Island, and Manhitas Island, and bounded on the east part by the main sea, and part by Hudson's river, and hath upon the west Delaware bay or river, and extended southward to the main ocean as far as Cape May at the mouth of the Delaware bay; and to the northward as far as the northermost branch of the said bay or river of Delaware, which is forty-one degrees and forty minutes of latitude, and crosseth over thence in a straight line to Hudson's river in forty-one degrees of latitude; which said tract of land is hereafter to be called by the name or names of New Cesarea or New Jersey: and also all rivers, mines, minerals, woods, fishing's, hawking, hunting, and fowling, and all other royalties, profits, commodities, and hereditaments whatever, to the said lands and premises belonging or in any wise appertaining; with their and every of their appurtenances, in as full and ample manner as the same is granted to the said Duke of York by the before-recited Letters Patents; and all the estate, title, interest, benefit advantage, claim and demand of the said

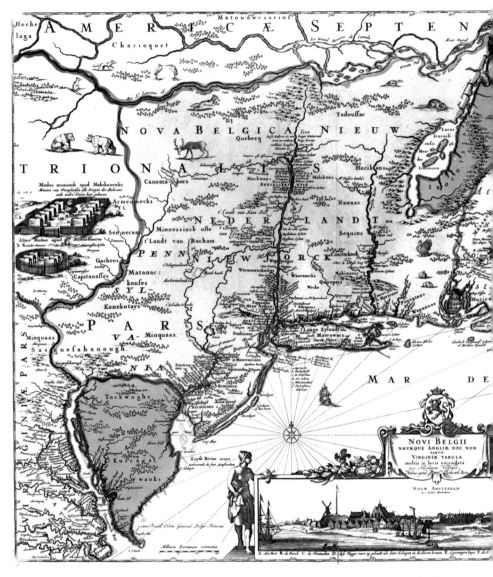

This circa 1656 map, drawn by Dutch cartographer Nicholas Visscher, was the basis for the boundaries drawn in the duke's grant. *Wikimedia Commons.*

James Duke of York, of in or to the said and premises, or any part or parcel thereof, and the reversion and reversions, remainder and remainders thereof: All of which said tract of land and premises were by indenture, bearing date the day before the date hereof, bargain'd and sold by the said

James Duke of York, unto the said John Lord Berkeley and Sir George Carteret, for the term of one whole year to commence from the first day of May last past, before the date thereof, under the rent of a pepper corn, payable as therein is mentioned as by the said deed more plainly may appear: by force and virtue of which said indenture of bargain and sale, and of the statute for transferring of uses into possession, the said John Lord Berkeley and Sir George Carteret, are in actual possession of the said tract of land and premises, and enabled to take a grant and release thereof, the said lease being made to that end and purpose, to have and to hold all and singular the said tract of land and premises; with their, and every of their appurtenances, and every part and parcel thereof, unto the said John Lord Berkeley and Sir George Carteret, their heirs and assigns for ever, to the only use and behoof of the said John Lord Berkeley and Sir George Carteret their heirs and assigns for ever; yielding and rendering therefore unto the said James Duke of York, his heirs and assigns, for the said tract of land and premises, yearly and every year the sum of twenty nobles of lawful money of England, if the same shall be lawfully demanded at or in the Inner Temple Hall, London, at the Feast of St. Michael the Arch Angel yearly. And the said John Lord Berkeley and Sir George Carteret for themselves and their heirs, covenant and grant to and with the said James Duke of York, his heirs and assigns by these presents, that they the said John Lord Berkeley and Sir George Carteret, their heirs and assigns, shall and will well and truly pay or cause to be paid unto the said James Duke of York, his heirs and assigns, the said yearly rent of twenty nobles at such time and place, and in such manner and form as before in these presents is expressed and delivered. In witness whereof the parties aforesaid to these presents have interchangeably set their hands and seals, the day and year first above written. JAMES

Sign'd, seal'd and deliver'd in the presence of
WILLIAM COVENRYE,
THOMAS HEYWOOD.

The description in this deed was seriously flawed. The boundaries of New Jersey ended in every direction once your feet got wet (the Hudson River,

the Atlantic Ocean, the Delaware Bay and the Delaware River) except for the northern boundary. The northern boundary seemed to be well defined by reference to points of latitude: forty-one degrees, forty minutes on the Delaware; and forty-one degrees on the Hudson. Just draw a line between these two points, and you have closure. Except the description was drawn in England by men who had never visited New Jersey, of land that few white men had ever seen and based on a 1656 map prepared by Nicholas J. Visscher, a Dutch cartographer who had never wandered beyond the confines of Europe. There had been no survey commissioned to establish the boundaries, so they were based on what was known at the time—which was very little.

This was not an unusual practice for the period. Maps of the New World were in great demand by adventurers and explorers, merchants and monarchs. The land across the sea was a great untapped resource, and people were thirsty for more information, regardless of its accuracy. The first map of the New World was prepared in 1507 by German cartographer Martin Waldseemuller. He drew it at his drafting table in Saint-Dié-des-Vosges, thousands of miles away from the newly discovered land, and he did it without the benefit of surveys; all he had was the narrative description in *Four Voyages of Amerigo Vespucci*. It was at that moment that the continents in the new hemisphere were named America. With that same leap of faith and limit of knowledge, the Duke of York relied upon the Visscher map, severing New Jersey from New York. This would result in land title disputes and open warfare between New York and New Jersey for the better part of a century.

The Nicolls Grants

Carre and Nicolls left England on May 25, 1664, heading for New Netherland. Nicolls had been given specific instructions and authorities by James, Duke of York. Chief among them was that after the capture of New Netherland, he was to settle and populate the Duke's land. He could not have possibly imagined that after less than a month at sea, the Duke would sever the dominion and convey "the most valuable portion" of it to Berkeley and Carteret.[23] Nicolls was a military man and set about his "mission" with determination, immediately issuing *The Conditions for New Planters in the Territories of his Royal Highness the Duke of York.*[24] This document reveals the intention of introducing the English system of landownership and

abandoning the feudal manorial system that the Dutch had unsuccessfully tried to implement. Eleven brief and simple precepts would set the stage for rapid settlement of the lands west of the Hudson River. Nicolls understood strategy and how to motivate men, so he made the rules simple and direct.

- All land must be purchased from the Indians and recorded with the governor.

Nicolls understood that only through proper relationships with the natives would long-term settlement have any chance of success. He also knew that all land title documents must be recorded and available for all to access in order to avoid later disputes.

- The purchasers had to obtain permission from the governor but did not have to pay for such right.

In this way, Nicolls could keep track of the negotiations and developments between the settlers and the natives, avoiding duplicity and arguments between settlers while at the same time encouraging settlement without imposition of burdensome fees. Nicolls was establishing a system of control. It was a vast, undeveloped land, and he wanted to avoid chaos.

- The purchasers had to set out a town and inhabit it together.

Surely, Nicolls was well aware of the disputes and wars with the Lenape by now. He wanted to discourage single homesteaders from venturing too far into the native territory without the support of a community of committed and like-minded associates. Nicolls wanted permanence. He wanted to avoid the mistakes of the Dutch. The English were here to stay.

- He offered a five-year tax abatement in order to motivate the potential settlers.

Nicolls understood the value of a permanent settlement. Five years was a reasonable period of time to develop a town, and after that, their success would pay returns tenfold as taxes were levied on the value of property. Once the property had been tilled, developed, managed and invested in for a period of years, the value would be far more significant than in its uncultivated form.

- "All lands thus Purchased and Posses'd shall Remain to the Purchasers and their Heirs as free-lands to Dispose of as they Please."[25]

There it is—the definition of fee simple land title ownership! No strings attached. Get a few friends, get permission from the governor, buy the land from the Indians, settle it and it's yours forever. This paragraph trumped all the others, including the one in which Nicolls granted liberty of conscience. While the liberty of conscience clause is certainly an incentive and benefit to prospective settlers, the earliest of them were already in America (Massachusetts, Rhode Island and Long Island) and had enjoyed a variety of religious freedoms. Some, like John Ogden, had been in Long Island for twenty years before coming to Elizabethtown.[26] It was not religious freedom they were looking for; it was economic opportunity and more and better land. However, regardless of their particular religious persuasion, all "householders and inhabitants of the Town" were required to pay for the minister, who would have been Anglican.

- Nicolls offered home rule.

Each town could "make their Particular Laws, and deciding all Small Causes within themselves." This, too, was an appealing benefit and uniquely English.

- "The Lands which I intend shall be first Planted, are those upon the west side of Hudson's River."[27]

Nicolls quickly recognized that settlement of the interior territories was critical in joining New England with the Virginia colonies. An overland route would be necessary to solidify these middle colonies within the North American British colonial empire. The sooner they explored and settled the lands west of the Hudson River, the stronger their position would be. He ignored Long Island and even the northern regions of Manhattan Island, knowing that they would develop naturally. Instead, he would subscribe to Horace Greeley's future advice, choosing to "go west and grow up with the country" almost two hundred years earlier.

- The final precept allows for the election of officers by the free men of the town.

This, of course, reinforces the previously stated home rule rights, but contained within this paragraph is a definition that would establish a precedent that would be repeated and reinforced throughout New Jersey's history up to and including the first constitution of the state of New Jersey in 1776. This document defines free men as "not Servants or Day-labourers, but are admitted to Enjoy a Town-lott." The requirement to own land in order to vote and hold office begins here and is repeated in a variety of colonial documents. Landownership was the gateway to success in colonial New Jersey—economically, politically and socially.

Very quickly, the flood of suitors would appear. Contingents came from Long Island, Northampton, Jamaica and Gravesend. The East Enders would be led by the venerable John Ogden (the progenitor of a family that would have a long and distinguished tenure in New Jersey) along with John Bailey, Daniel and Nathaniel Denton, Thomas Benedick, John Foster and Luke Watson. They had previously approached Peter Stuyvesant in an attempt to acquire some of the prime land west of the Hudson River, but it came to naught.[28] Now, the English were in charge and eager to make a deal. As previously noted, Nicolls wasn't asking for the East Enders to purchase the lands from him; they had to go and convince the Indians. On October 28, 1664, John Bailey, Daniel Denton and Luke Watson found the Lenape sachems Mattano Manamowaouc and Couesccoman in Staten Island and struck a deal for roughly 500,000 acres of land in New Jersey between the Raritan and Passaic Rivers.[29] A consideration of "twenty fathoms of trading cloth, two coats, two guns, two kettles, ten bars of lead, and twenty handsful of powder and four hundred fathoms of white wampum."[30] On December 1, 1665, Nicolls confirmed the Indian purchase with a royal grant in his capacity as governor on behalf of the Duke. This document is the first in a series of grants issued by Nicolls, which created land title defects. From its very inception, New Jersey's land title system was corrupted! Nicolls was conveying land that the Duke hadn't owned for over five months.

The second group to obtain a Nicolls grant hailed from Gravesend (Brooklyn), located directly across from Sandy Hook, and the desirable lands along the Navesink and Shrewsbury Rivers. These were excellent lands for farming, husbandry and fishing, with ports that were protected from the ravages of the open sea by a barrier island. This contingent, led by John Bowne and joined by William Goulding, Richard Gibbons and Samuel Spicer, had visited the Navesink in December 1663 to negotiate a land purchase with the natives.[31] It is suggested that they already knew Charles II

had designs on New Netherland and was preparing to seize it. They wanted to be the first in line for the best land. They made several trips to the area, in defiance of the Dutch sovereignty, during which they acquired three tracts of land from the Indians for a total cost of 508 pounds, 16 shillings and 10 pence in goods and services. The consideration included wampum, "black and white peague, huns, one anchor of brandy, tobacco, clothing, wine."[32]

They were a determined bunch and were happy to bring their Indian deeds to Governor Nicolls and make petition for a patent. On April 17, 1665, Nicolls did issue the "Monmouth Patent" to William Goulding, Samuel Spicer, Richard Gibbons, Richard Stout, James Grover, John Bowne, John Tilton, Nathaniel Sylvester, William Reape, Walter Clark, Nicholas Davies, Obadiah Holmes.[33] Within five years' time, the settlement would expand to over 145 men and their families. This was the second major defective title established unwittingly by Richard Nicolls. He was still unaware that James had sold New Jersey to Berkeley and Carteret. He had also issued a smaller grant of five hundred acres to Dutch expatriates Nicholas Jansen and Samuel Edsall at Constable's Hook.[34]

When Governor Philip Carteret, a young man of twenty-six and distant cousin to Sir George Carteret, arrived ashore at Elizabethtown on August 1, 1665, the settlers were wary and concerned. He had been given a commission and a governorship to this new land of Jersey. Carteret had already stopped off in New York and broken the news to Nicolls that he was being forced to give up his involvement in the province. Carteret discussed the title issues with the associates, and they were convinced that all was understood.[35] Philip Carteret went so far as to buy John Bailey's "third lot right," which is based on the Indian deed and the Nicolls grant, for himself. Everyone seemed to be in agreement, but a storm was brewing. Quit rents would be demanded; titles would be denied; disputes with New York would arise; Philip would be abducted in the middle of the night, beaten, tried in New York, found innocent and returned, only to later die from his wounds; the province would be split in two; new sets of proprietors with very different ideas would come into power; there would be armed conflict along the northern border and between East and West Jersey; lines would be drawn, redrawn and redrawn again; land riots would flare; tar would be heated and feathers plucked, lawsuits filed and kings edicts' handed down as New Jersey steadily charged toward a great revolution. It is this tradition of intense conflict fomented over land title disputes that both inured the populace to the impending rebellion and at the same time drove them away. New Jersey's century-long land title disputes acted as a Petri dish for many of the principles of self-

determination, superiority of property rights and equality that would fuel the American movement for independence. New Jersey was not so strident as the New Englanders or as genteel as the Virginians, but at the end of the day, more of the Revolution was fought on this land than anywhere else in the colonies.

While the Dutch were pursuing their commercial enterprises through the patroon system in New Netherland, the English were engaged in a series of social experiments in the Massachusetts Bay and Virginia colonies. They would learn many valuable lessons between 1607 and 1664, the most important of which was the promise of fee simple land ownership. It alone, and not the commercial enterprise of vast tobacco plantations or the theocracy that resulted from religious refugees escaping oppression, would ensure permanent and significant settlement. In the end, it was all about economic survival and mobility. After the English conquest of New Netherland in 1664, Nicolls and the proprietors fully comprehended the necessary elements for a successful colony in America: offer access to fee simple ownership in large tracts of land, purchase the title rights from the aboriginal owners, allow home rule and a level of self-determination and make landownership the gateway to wealth and power in New Jersey.

Chapter 2

CHILDREN AS CHATTEL: THE PUTTING OUT OF FRANCIS JACKSON'S CHILDREN

"Boy," said the gentleman in the high chair, "listen to me. You know you're an orphan, I suppose?"
—Charles Dickens, Oliver Twist

In *Oliver Twist*, Charles Dickens vibrantly exposes the nineteenth-century orphanages of the Industrial Era. Other than the musical theater that was added after the fact, the life of an orphan was a rather dreary existence. These institutions did not proliferate until well after the American Revolution. What was the fate of an orphan at the dawn of the New Jersey province in the seventeenth century? Having just traveled across a great ocean and settling in a rugged and mysterious land, what would happen to a boy whose mother had died in childbirth and whose father had been crushed by a wagon full of timber?

This was not an unusual occurrence for the time. On page eighty-seven of Deed Book D at the Monmouth County Clerk's Office can be found the court record of the "putting out of Francis Jackson's children" in September 1698. It seems poor Francis passed away, leaving four children without a mother. "Putting out" was the preferred method of dealing with orphaned children at this time. It made a place for the child in a home that would hopefully love, nurture and teach him/her a trade. It would provide the host family with an additional cheaper labor force to help sustain them; it was certainly less expensive than hiring an adult indentured servant and usually more compliant than purchasing a slave. It was well suited to the predominantly

A 1698 document regarding the "putting out" of Francis Jackson's children, as recorded in the Monmouth County land records. *Photograph by Heather Paich.*

Quaker community of Monmouth, whose communal tenets embraced the care of the needy. But make no mistake—this was not adoption. There was no guarantee of compassion. The children were placed with members of the community who were able and willing to assume the burden. In 1698, it was a very small community, and options were limited. There were no meetings with social workers, home studies or fitness evaluations. Children were put out based on the needs of the host families, not their own.

The first of the children to be put out was William. At seven years old, he was apprenticed to George Allen, who was tasked with the job of instructing William in "ye art and mystery of a weaver." William was bound until he attained the age of twenty-one and was to be provided with "good suficent meate, drink, washing, lodging and apparel." The Allens also promised to teach him to read, write and "sifer." His sisters, Mary and Elizabeth (each

twelve years old), were put out until they became eighteen or got married. Females were considered a greater burden and were expected to look for marriage well before their eighteenth birthday. They would learn to read, knit and sew, receiving the obligatory two suits of clothing when their time was up. The fourth child, Francis Jr., was only thirteen months old. Samuel Leonard, the administrator of the estate of Francis Jackson, arranged for the toddler to be put out to Francis and Jane Bordin, the same family as Elizabeth. So for the next six years, he would have the comfort of his sibling. However, the Bordins were not opening their home to Elizabeth and Francis without compensation. They would be paid the sum of twenty pounds in money and household goods by the administrator of the estate. Both children would be servants—Elizabeth for six years and Francis Jr. until he turned twenty-one. Elizabeth would be taught to read, knit and sew, while Francis Jr. was instructed in the art of husbandry. Both would get two suits of clothing when they left. Elizabeth would receive an additional eight pounds in money, which she would need as a dowry. A girl of eighteen with no family or means of support, Elizabeth would have to find a husband quickly.

The record does not indicate whether any of these families had other children with whom the apprentices would have to contend or merely childless couples looking to bring a poor unfortunate youth into their homes. At the end of the seventeenth century, Monmouth was a rough and unsown frontier. There was plenty of need for apprentices and servants. With a large Quaker population in Monmouth, some might have chosen to engage white children as servants rather than import black slaves, thus avoiding a moral and religious dilemma.

Three decades earlier, in May 1669, young Mathew Howard, a boy of only "seven years or thereabouts," had been sent away from his home by his mother and apprenticed to Henery Percy and his wife, Kathern, to become a blacksmith. His father had passed away, and his mother probably thought she was doing the right thing by allowing Mathew to learn a trade and acquire prospects for the future. The full contents of his indenture (not to be confused with a deed of indenture)[36] are recorded on pages thirteen and fourteen of Deed Book A. This agreement was a business transaction; he was not an orphan, and he was not being adopted. He was a bonded employee. If he were lucky, he could expect to be treated as a servant. At worst, Henery Percy would work him to the bone. Mathew would have to spend the next fourteen years of his young life living with the Percys and toiling without pay—just the promise of clothes on his back, a roof over his head, food on his plate and long, hard days serving his master. There is no provision for learning how to read or write in this indenture. At the age of

A 1669 document regarding the "putting out" of Mathew Howard, as recorded in the Monmouth County land records. *Photograph by Heather Paich.*

twenty-one, Mathew would be a free man with a trade and receive a set of blacksmith tools (bellows, anvil, hammer, etc.) and two new suits of clothing, one for "ordinary days" and the other for church.

Monmouth County has the oldest existing collection of county land records in the state, beginning in 1667, followed by Essex, beginning in 1683. In the case of Monmouth, the Shrewsbury and Middletown township records were incorporated into the county land records, revealing that there were not only early deeds recorded in the township records (as can be found in towns like Newark and Woodbridge) but also a variety of other documents that open an otherwise unknown door to the peculiarities of life in the late seventeenth century.

Chapter 3

GUNS AND ANKERS FOR LAND: NATIVE AMERICAN LAND TRANSFERS

It hath been generally observed that where the English come to settle, a Divine Hand makes way for them, by removing or cutting off the Indians, either by Wars one with the other, or by some raging mortal disease.
—Daniel Denton, Elizabethtown Associate

Humans have inhabited this land we call New Jersey for over twelve thousand years.[37] To provide some frame of reference, in 8700 BC, Native Americans, at this time known as Paleo-Indians, were occupying the Shawnee-Minnisink Camp on the Delaware River near Stroudsburg, Pennsylvania. The rest of the world was experiencing the Neolithic Age or New Stone Age. This was the time when people began to engage in agriculture in places like the Fertile Crescent and started using fire to make pottery and bricks for building. Over time, other world civilizations moved forward, yet the Native North Americans remained in the Stone Age right up until the Europeans arrived in the fifteenth century.

An argument can be made that the simplicity of the Native American culture was its beauty, which was corrupted when the Europeans came to the Americas. Some would say that it would be their downfall, having to adapt and transition their ten-thousand-year-old culture over the course of a few decades. It was a cultural tsunami. It would be as if aliens from another universe were to land on earth today with technologies, philosophies, cultures and a system of laws that was thousands of years more advanced. The natives did not have the wheel, and contrary to visions from old westerns,

the horse would not arrive until the Europeans did. They walked wherever they went or used canoes to travel along the rivers and streams. One of the most significant advancements that would cause the Native Americans confusion and disruption was the European system of landownership and land transfer, and at the heart of that was the written word. The Native Americans did not have a written language; theirs was an oral tradition. This tradition was, of course, subject to alteration, embellishment, time and interpretation. The English documentary system left little to be interpreted. Of course, if one of the parties was unable to read or write English, they could ascribe myriad interpretations to each document.

The total Indian population when the Europeans arrived was between 2,400 to 6,000 people, or roughly 1 person per three square miles.[38] Today, there are approximately 1,200 people for every square mile. The population of London at that time was around 200,000. The Lenape had little sense of the multitudes that would arrive over the next few decades. They were generally known as a peaceful people, only having disagreements with the Dutch, who failed to reconcile with the aboriginal inhabitants. Noted English legal scholar William Blackstone would describe the Native American concept of landownership as "in common among them, and that everyone took from the public stock to his own use such things as his immediate necessities required."[39] The Lenape believed in the concept of "a time in land" or "while I am here, this land is mine." This concept is similar to a movie theater seat. When you walk into the theater and take your seat, you don't expect someone else to sit in it. It is "your" seat. However, if you return the next day, you don't expect that that seat will be available. If it is, it becomes your seat again.

The Europeans had a complex tradition of landownership that can be understood as "land for a time." This means that an individual owns and controls this land for the period of time determined by him, regardless of physical possession, continued use or ability to defend it against interlopers. It was about the subject of landownership that these cultures would significantly and tragically collide. The peaceful Lenape, who were not fluent in Dutch or English, did not have a written language, did not subscribe to the same philosophy of landownership, were assumed to understand the complexities and consequences of placing their mark (X) on a piece of parchment.

However, the Europeans did understand, and they made sure that the land rights of the Lenape were acquired prior to obtaining grants for land in the colony of New Jersey. The earliest conveyance from the Lenape to the English was made by Mattano, a sachem/chief, on October 28, 1664.

This land comprised 500,000 acres and would become the Elizabethtown Purchase. The consideration in that deed was "twenty fathoms of trading cloth, two coats, two guns, two kettles, ten bars of lead, and twenty handsful of powder and four hundred fathoms of white wampum."[40]

Mattano might have found some amusement in the bargain, as he was getting so much for so little. He might also have been in good spirits, as the considerations in almost every Indian deed conspicuously included several ankers of rum, barrels of beer or other liquor! The question, of course, is at what point in the "negotiations" did they crack open the keg? In 1719, the surveying of the New York–New Jersey border was interrupted by some suspicious Indians who were concerned about being swindled. One of the surveyors noted, "We had several arguments pro and con with them…before we could be allowed to proceed, we [were] forced to give them rum. This brought about the cooperation of the natives."[41] It was none other than the great Benjamin Franklin himself who said, many years later, "And indeed if it be the Design of Providence to extirpate these Savages in order to make room for Cultivators of the Earth, it seems not improbable that Rum may be the appointed Means. It has already annihilated all the Tribes who formerly inhabited the Sea-Coast." Franklin went on to further describe the affects of alcohol on the Native Americans that he witnessed at Carlisle in 1742 after they had concluded a treaty:

> We found they had made a great Bonfire…They were all drunk, Men and Women, quarrelling and fighting. Their dark collored [sic] bodies, half naked…running after and beating one another with Firebrands, accompanied by their horrid yellings, formed a scene the most resembling our Ideas of Hell. There was no appeasing the Tumult. At midnight a number of them came thundering at our door demanding more Rum.[42]

The influence of alcohol in land transactions and relationships with the Native Americans should not be underestimated. There were two other major consequences of the Lenape interaction with the whites. The exposure to European diseases caused a massive reduction in their tribal population, and after years of brisk trading with the Europeans for their goods, the Lenape culture had become increasingly dependent on those superior tools, weapons and cloths. By 1715, they had conveyed away most of their title interests to land in New Jersey. The Indians had been trading with the Europeans since the early 1500s—mostly with trappers, as the fur trade was booming in Europe. The trappers traded all sorts of manufactured

A Native American stone axe head. *Courtesy of the New Jersey State Library.*

goods for these pelts, none of which the Indians had ever seen. The most prized item was an iron hatchet. For the Indians, who were still living in the Stone Age, it could take over a month of intermittent work to make a stone axe. This involved finding the right stone and then grinding it to a point of being useful. However, the first time it was used to cut down a tree, it might shatter. The iron axe obtained from the English fellow for making an "X" on the deerskin didn't break and performed wonders. It was also lethal in battle. The Lenape were all too willing to trade away their land rights for these superior goods.

Imagine the unbridled laughter around the campfire when each Lenape, in turn, tells his story of how he bamboozled the white men into giving him guns, knives, axes and rum for making a scrawling mark on the parchment. They could stop wearing animal skins, cook over high flames without their pottery cracking, chop down trees and build homes in a quarter of the time, plow their fields in half the time, clear more land and grow more crops. They could even use metal drilling awls to make more wampum!

The romantic vision of the helpless, naïve and simple native being cheated out of their land is not always applicable to the colonial experience in New Jersey. There are two particular transactions in Monmouth County that are most noteworthy. The first is a five-page, 315-year lease dated March 1684 between sachem Iraseeke of Wickaton and William Leeds and Daniell Applegate for a large tract of land that is described in miles.[43] The annual rent to be paid for this lease was "four yards of Duffield or the equivalent in rum," to be paid on the Feast of All Saints or Hollandtide. Certainly, Iraseeke could not expect to live for another 315 years, if he even fully grasped the concept of exactly how long that was.[44] He might have known that November 1 was the Feast of All Saints; however, one must wonder if he possessed an English calendar. Even considering the exchange rate and inflation since 1684, four yards of duffel cloth annually seems to be a meager payment for the use of so much land for such a long time, especially when factoring the opportunity to replace payment with an alcoholic beverage.

Iraseeke was, however, no fool. For in that 315-year lease, he specifically retained the right to visit Leeds or Applegate at their homes and borrow a gun for a period of forty-eight hours, provided he give them half of whatever he killed. This reveals a special relationship between Iraseeke, Leeds and Applegate. The fact that these white men trusted an Indian with a firearm for only forty-eight hours exposes the limits of that relationship. That they demanded half of the catch indicated their recognition of Iraseeke's superior hunting skills and their wish to take further advantage of the underlying transaction. That a land lease would contain this type of ancillary agreement, predicated upon the honor system, reveals the intricacy and depth of the bonds between Europeans and Native Americans. They would have to trust Iraseeke to return the gun and surrender half of the bounty. This minor addendum to a real estate transaction is, in many ways, far more important than the transfer itself. It reveals the influence that European technology had on the Native Americans, as well as the value it held. The ability to borrow a firearm for a couple days might seem like poor compensation for the lease of hundreds of acres of land, but to Iraseeke, it was worth it. The English were concerned with an abstract concept of land "ownership"; Iraseeke was concerned about the very real prospects of survival. His access in 1684 to a firearm made him an important and respected personality within his social framework. It also exposes the treaty-like nature of many land transactions between the natives and the Europeans.

For a culture that had no written language and preserved their histories through song and story in the oral tradition, the anthropological value

The 315-year lease between Lenape sachem Iraseeke and settlers William Leeds and Daniell Applegate, as recorded in the Monmouth County land records, 1684. *Photograph by Heather Paich.*

of these land transactions cannot be ignored. The written documents were, of course, prepared by the English and therefore decidedly tainted by their influence. But behind every document, there is a negotiation, an interaction that results in the final text. Those negotiations are influenced by each party's cultural knowledge. For the Native Americans, the verbal understandings of the deal might have been somewhat different than what was memorialized in the deed. How could they be sure, since they could not necessarily read the final document? As they sat around the council fire or in the meetinghouse or a settler's home, many matters were discussed, with some influence of the ubiquitous rum that was provided for payment. Some measure of the transaction might have remained unwritten or assumed by the Native Americans.

The second deed was dated January 14, 1686, the dead of winter. It details that Edward Webley went to visit Shougham, sachem of Craswicks, to negotiate the purchase of one thousand acres of land near Crosswicks.[45] The description in the deed is vague and unplottable, calling to white oaks marked with the letter "T," up a creek to its head, across meadows to a black

oak tree marked on three sides and so on. In the presence of two white men, Shougham made his mark. For all of this, Edward Webley paid "ye sum of ten pounds or ye vallew of it in goods." The very next day, January 15, Edward Webley sold the entire parcel to Thomas Webley for the sum of fifty pounds. It is apparent that they had misled Shougham as to the actual value of the property.

The Indian deeds as records of early land acquisition by the English settlers are crucial to understanding the development of the province and later state of New Jersey. Eliminating the Native American claims to all land in New Jersey was demanded by the Dutch and English proprietors. In 1683, the English proprietors gave explicit instructions to Deputy Governor Gawen Lawrie that the province "be freed of all Indian encumbrances and purchased from them out of the company's stock, but that no opportunity be omitted of purchasing more land from the Indians until the whole Province be bought from them."[46]

The Europeans went about this with vigor, and in just fifty-one short years, the vast majority of the New Jersey land titles had been transferred from the Native Americans to the English. There are 152 Indian deeds found filed in the Colonial Conveyances, the majority of which are dated prior to 1715. In the short period between 1664 and 1715, the Lenape had deeded away almost 90 percent of New Jersey. The white population in 1700 was no more than 20,000 (2.5 people per square mile).[47] Even though the Lenape had deeded away their land rights, they had yet to fully realize the impending population of New Jersey by whites. The Lenape had no idea that at that same time across the ocean there were over 500,000 people in the city of London alone. Within the next one hundred years, over 180,000 settlers would invade New Jersey.

With no land rights left to barter with, the Lenape became despondent, desperate and, worst of all, dependent on the white man. By 1745, there were fewer than four hundred natives remaining within New Jersey. The rest had died, been killed or moved north and west. In 1758, due to the hostilities of the French and Indian War and claims by the Lenape on both sides of the Delaware River that they had been treated unfairly and cheated in their land dealings, there were conferences held in Easton, Pennsylvania, and Crosswicks, New Jersey, to settle these disputes. The governors of both colonies were in attendance, along with the various Lenape sachems who had come from all over to attend. The sachems claimed that "they were wronged out of a great deal of land…if we have been drunk, tell us so…We have, here and there, tracts of land, that have never been sold. You claim all

the wild creatures, and will not let us on your land to hunt. You will not so much as let us peel a single tree: This is hard."[48]

The conferences ended with the signing of treaties relinquishing all remaining Lenape land rights in New Jersey and calling for the creation of a safe haven for the native peoples of the colony. The Lenape received a consideration of 1,000 Spanish dollars, placed in trust. In conclusion, Minsi sachem Egohowen, apparently still somewhat in the dark about the full comportment of these treaties, said:

> We are now thoroughly satisfied…and we desire, that if we should come into your province, to see our old friends, and should have occasion for the bark of a tree to cover a cabin, or a little refreshment, that we should not be denied, but treated as brethren. And that your people may not look on the wild beast of the forest, or fish of the waters, as their sole property; but that we may be admitted to an equal use of them.[49]

Almost one hundred years had passed, and after all the cheating, swindling, inebriating and depredations, the Lenape still did not seem to fully grasp the totality of the English principle of fee simple title. Through the efforts of Reverends David and John Brainerd and the New Jersey Association for Helping the Indians (Quakers), in 1758, the provincial government purchased some three thousand acres of land in Burlington County near what is currently known as Indian Mills (Route 206) for the purpose of establishing the Brotherton Reservation.[50] Over one hundred Lenape settled there, but by 1802, they had all abandoned the reservation and joined their brethren, the Stockbridge-Munsee, in New York State.

In 1832, Bartholomew S. Calvin, a graduate of Princeton University and grandson of sachem Wequahelic, petitioned the New Jersey legislature claiming to represent the remaining Lenape land and fishing rights, which were not extinguished under previous conveyances and treaties. The legislature stood steadfast upon its position that New Jersey had properly remedied those interests, but it conceded in granting the sum of $2,000 "as an act of voluntary justice…and as a consummation of a proud fact in the history of New Jersey, that every Indian claim, right and title to her soil and its franchises, have been acquired by fair and voluntary transfer."[51]

The record of the Indian deeds stands as the most comprehensive contemporary written account of colonial interpersonal relationships among the English settlers and natives of New Jersey. The complexities of each transaction would have been very difficult to relate in song and story, so the

A Josiah Foster map of the tract depicting the subdivision of the former Brotherton Reservation in 1802. *Taken from Woodward and Hagamen's* History of Burlington and Mercer Counties, New Jersey *(1883).*

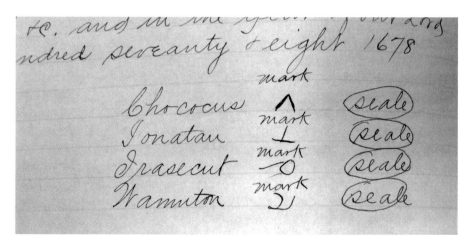

Marks (signatures) made by various Lenape sachems on land deeds in Monmouth County. *Photograph by Heather Paich.*

native experience is anecdotal at best. These deeds provide the names of the most prominent Lenape men, as well as their tribal associations and authority. Further examination of this resource is warranted in order to provide greater insight into the dispossession of the New Jersey native peoples.

Final Note

After two hundred years, the complete extinguishment of all land title claims by the Lenni Lenape has come into question. A recent decision by the U.S. Court of Appeals for the Third Circuit in the matter of *Unalachtigo Band v. Corzine, 606 F. 3d 126 (3d Cir 2010)* has (at least for the immediate future) resolved a claim by Native Americans to a large parcel of land in Shamong Township, Burlington County, formerly known as the Brotherton Reservation. The Third Circuit affirmed the dismissal of the complaint on the grounds that the plaintiffs lacked standing. However, it failed to rule on the underlying argument that the 1801 conveyance of Brotherton on behalf of the Lenape violated the 1789 Indian Non-Intercourse Act because the sale of Indian lands is void if it is made without congressional consent.[52]

Chapter 4

COLONIAL CURRENCY AND THE LAND BANK: THE BIRTH OF THE MODERN LAND RECORDING SYSTEM

Traveling through the record room and courthouse, one might wonder about the significance of two dates: 1766 and 1784. Those are the years that most often appear on the earliest mortgage and deed indexes, respectively. It is a curious choice of beginning points for the land records. Written land conveyances in New Jersey have existed ever since 1630, when Michael Pauw purchased what is today Jersey City from the native Lenape. The English came in 1664 and began issuing land patents almost immediately. The Westchester County (New York) Clerk's Office land records begin in 1684. Yet it would appear that it took over one hundred years for New Jersey to establish a reliable recording system for the mortgages and deeds that were so vital to the settlement and development of this province. Why mortgages in 1766 and then deeds almost twenty years later in 1784?

In 1664, Berkeley and Carteret issued *The Concession and Agreement of the Lords Proprietors of the Province of New Caesarea, or New Jersey, to and with All and Every the Adventurers and All Such as Shall Settle or Plant There* for the purpose of establishing a set of rules for settlement and incentivizing those adventurers to come to the province. It is a lengthy document with great particularity comprising forty-six paragraphs, sixteen of which deal specifically with land. One section addresses the security of title and possession:

> *AND THAT THE LANDS MAY BE THE MORE REGULARLY LAID OUT AND ALL PERSONS THE BETTER ASCERTAIN'D OF THEIR TITLE AND POSSESSION*

> *II. Item…The Surveyor General, or his deputy, shall proceed and certify to the chief Secretary or Register, the name of the person for whom he hath laid out land, by virtue of what authority, the date of the authority or warrant, the number of acres, the bounds, and on what point of the compass the several limits thereof lye; which certificate the Register is likewise to enter in a book to be prepared for that purpose, with an alphebettical [sic] table, referring to the book, that so the certificate may be the easier found; and then to file the certificates, and the same to keep safely.*

This section goes on to specify the particular form for the land grant and that after it is signed and sealed, "then the instrument or grant is to be by the Register recorded in a book of records for that purpose."[53]

From the beginning, the proprietors understood the importance of land records and a system for maintaining them in protecting the title rights acquired thereunder. However, these books were for the purpose of the sellers/proprietors to keep track of the land they were conveying. They were private, not public, records and remained so for centuries.[54] The West Jersey proprietors took similar actions under chapters V and XXIV of their Concessions and Agreements of 1676 with the peculiar addition of a duplicate register at London. Deeds and conveyances could be registered in London, and once every year, the London entries would be transmitted to the commissioners of West Jersey "to be enrolled in the publick register of the Province."[55] The chapter ends by stating, "And all other conveyances, deeds, leases, or specialties not recorded aforesaid, shall be of no force nor effect."[56] It is obvious how this one-year "hole" in the provincial records could cause more than a few property disputes.

In 1683, under *The Fundamental Constitutions for the Province of East New Jersey in America*, the twenty-four proprietors who succeeded to the rights of George Carteret took the step of mandating a public register in each county (of which there were only four at the time) and further proclaimed that failure to register a document there within six months would be considered void:

> *XVIII. All chart, rights, grants and conveyances of land (except leases for three years and under) and all bonds, wills, and letters of administration and specialties above fifty pounds, and not under six months, shall be registered in a publick register in each county, else be void in law.*[57]

Even with the best intentions, these attempts at a recording system were generally confusing and ineffective. Also important to note is that a register is quite different than a recorded document. A register is a type of ledger that contains brief abstracts of the contents of the document. Under the 1664 concessions previously cited, there is reference made to a register, an alphabetical table and the certificates—three separate but related records. Under chapter IV of the Laws of East Jersey, passed in 1698, the public records of the province were removed to the capital in Perth Amboy:

> *And that the register shall make exact entries in fair books of all publick affairs, and shall record all grants, or patents for land, and all other deeds or conveyances of land within this Province: Which deeds, the respective persons shall be obliged to record in the said office within six months after the date…which deed or deeds so recorded, shall be good and effectual in the law notwithstanding any other conveyance of the same land, tho' dated before such deed so registered.*[58]

This law was the statutory beginning of what is now recognized in New Jersey real property law as the "race-notice" system. In this system, he who records first gets first because he who recorded second ostensibly had notice of the prior conveyance, as a prospective purchaser has an obligation to perform due diligence in the land records.[59] This was no doubt a reaction to the growing land title disputes, general societal disruption in the later part of the century due to the seizure during the Third Dutch War and the English Revolution of 1688 and an attempt to control the land records and, thereby, the land titles. This will be a recurring theme up to and during the American Revolution. At this point, entering the eighteenth century with the royal assumption of provincial government only a few years away, there were mixed signals about when, where, what and with whom a deed should be recorded or registered. There were two different provinces with two separate capitals (Perth Amboy and Burlington) and two separate registers with which to lodge a deed. If one lived in Perth Amboy but purchased land in West Jersey, could he record his deed in Perth Amboy? Or would he have to travel all the way to Burlington? If living in northwest Jersey, which was alternately claimed by both East and West Jersey, where were the deeds recorded? What if it was a particularly harsh winter and travel to Burlington was not possible for six months—did he lose his title rights? In many instances, deeds never got recorded at all. Instead, they were kept safely in the family Bible and were mostly deeds of

indenture so that, when presented, they could be matched with the seller's half of the document to prove a valid chain of title.

It is not unusual to find deeds recorded years after their date for a variety of reasons. On April 30, 1917, Edward C. Taylor brought two deeds to the Monmouth County Clerk for recording. His late father, Henry, had possessed 172 acres of land in Middletown, and even though Edward was the youngest of four siblings, the settlement of the estate was left to him as the only son. What he found probably surprised him. The homestead farm, located right on Kings Highway in the village of Middletown, where six generations of Taylors had lived and worked since 1716, had no recorded title evidence. No deeds were recorded in the Monmouth County Clerk's Office to prove that the Taylor family was the rightful owner of all that land. Edward searched through two hundred years of family records and found the deeds, one from 1716 and the other from 1739.[60] By a special legislative act, these ancient deeds were allowed to be placed on record along with a specific affidavit of ownership and possession executed by Edward.

The deed records in the Middlesex County Clerk's Office begin in 1784 and the mortgages in 1766. Yet languishing in the archival holdings of our state university in New Brunswick is a road return book with "Early Records—1714—Middlesex County" marked on its binding. When the book is inverted and read from the "back," there can be found a series of deeds dating back to 1706. Middlesex was one of the original counties laid out in 1683—could this be one of the registers that were referred to in the previously mentioned acts? Alas, it is not.

It happens that 1714 was a very active year for the colonial legislature, passing thirty-seven acts ranging from "An Act for Regulating Slaves" to "An Act to Prevent the Concealing of Stray Cattle or Horses." As a matter of fact, 1714 is significant as one of the most prolific years between 1703 and 1745 for new legislation. On March 15, 1714, the "Governour, Council and General Assembly" passed "An Act for Acknowledging and Recording of Deeds and Conveyances of Land within Each Respective County of This Province."[61] The province now included all of New Jersey. This act recognized that "there is no Records of Deeds and Evidences of Lands kept within the respective Counties." To that end, the legislature empowered the clerk of the court of common pleas of each county to keep a book or books for the recording of "Deeds, Conveyances and Evidences of Lands" while at the same time reaffirming the right to record all of the same with the secretary of the province, thereby creating two coincidental recording offices. The confusion among land recording offices began in earnest at an

early age. The government in 1714 was admitting that despite the former acts passed in 1664, 1676, 1683 and 1698, no county land recording system had ever been properly established. With the rapid expansion of the province and the increased number of land transactions, action needed to be taken to alleviate the considerable travel burdens on property owners and create a system in which these important documents could be readily accessed for examination and production in the event of land title litigation.

Because the royal colony of New Jersey was but an extension of Mother England, all laws were required to be sent to the king for his approval and affirmation. Therefore, in 1714, this act for recording deeds was placed on a ship to make the long voyage across the Atlantic. Meanwhile, life in the colonies moved forward. On May 5, 1714, John Barclay, clerk of the court of common pleas of the counties of Middlesex and Somerset, did open Liber A of Deeds and Conveyances at Perth Amboy and accept for recording therein a deed dated November 20, 1706—a deed that had lain unrecorded for some eight years. John Barclay had no way of knowing that on January 20, 1721, King George would disallow this act. After various bureaucratic delays and another two months on the high seas, the king's nullification would arrive back in New Jersey over eight years later, thus creating an anomaly in the land title records. The last deed in the book was "entered" on April 26, 1722. This book cannot be found in the Middlesex County Clerk's Office, although by rights, it should be residing there since the county clerk is the titular successor to the clerk of the court of common pleas.

In 1727, the provincial legislature again passed and submitted an act that allowed the clerks of the court of common pleas in each county to record deeds in addition to the provincial secretaries. However, this was also disallowed by the king and so came to nothing.[62] But none of this explains the strange dates of 1766 and 1784. Looking to the Conveyancing Act of 1799, the genesis of New Jersey's modern Recording Act, surely there must be an answer there. But alas, it provided very little guidance. History must offer an answer to this query. England enacted the Stamp Act in 1765, which eventually led to American independence, and the Treaty of Paris was signed in 1784, officially ending that same war. But what does that have to do with recording mortgages and deeds in New Jersey? Absolutely nothing!

For the answer, it was necessary to go back to 1723 and explore a much larger issue—the economic woes of the province and its lack of specie or currency. New Jersey had no provincial monetary system; as a matter of fact, the consideration in deeds at that time was usually set forth in New York money. Without a viable form of currency, New Jersey was slipping into an economic

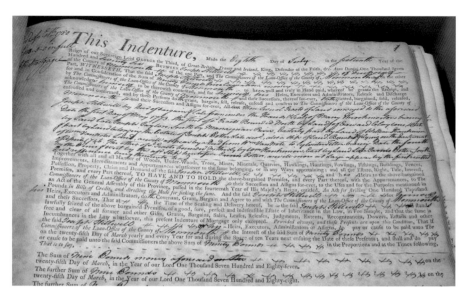

Monmouth County Loan Office mortgage. *Courtesy of the Monmouth County Archives.*

malaise. The colonial assembly referred to it as "the Miserable Circumstances of the Inhabitants…for Want of a Medium of Trade or Currency of Money."[63] So officials decided to open up loan offices in each county, which would issue bills of credit up to the value of £40,000. Another term for a loan office was a "land bank" because it secured the bills of credit with mortgages on land. A separate office was set up in or near the courthouse in each county. Then, a set of three commissioners was appointed and a clerk named. The landowners would come to the land office with proof of ownership, and the commissioners were required to "make due Enquiry into the Value thereof" and "examine the Titles thereto."[64] These commissioners were most likely the first official title searchers. The law entitled "An Act for an Additional Support of this Government and Making Current Forty Thousand Pounds in Bills of Credit for That and Other Purposes Therein Mentioned" is one of the largest and most complex laws of the early part of the eighteenth century.[65] It outlines in painstaking detail how the process worked. A mortgage would be signed by the landowner in a special prebound book in an amount not to exceed £100. The property put up as collateral had to be valued at least twice the amount borrowed and be without other mortgages or encumbrances.

The loan office issued bills of credit in denominations from one shilling up to three pounds. These bills would be legal tender for a period of

Above: Fifteen shillings of New Jersey proclamation money issued in 1776. *Courtesy of the Monmouth County Archives.*

Left: A colonial six-pound New Jersey note issued in 1761. *Courtesy of the Monmouth County Archives.*

Opposite: A three-pound New Jersey note. *Courtesy of the Monmouth County Archives.*

twelve years, repaid in annual payments plus 5 percent interest. The bills of credit could then be passed from "man to man" as currency. At the end of twelve years (sixteen years under later acts), whoever held the bills would redeem them at the loan office for the face amount. New Jersey would pass three more acts in 1732, 1735 and 1775 for the issuance of more bills of credit.

But as often happens when the government continues to print money, inflation set in and hard times returned. And so that brings us to 1765. At this point, the loan office system had broken down, and acts of fraud and counterfeiting had become more prevalent. In the original act, a penalty for counterfeiting was set forth: "They shall incur the Pains and Penalties of Felony, without benefit of Clergy, and shall suffer Death accordingly."[66]

Inscribed on a 1776 note was the warning "Tis Death to Counterfeit." In Morristown, a man named David Reynolds, a thirty-two-year-old native of Ireland, was in fact executed for counterfeiting bills of credit. He was a former accomplice of a man by the name of Rescrans, who was also previously executed for the same crime. Something had to be done; it was a moment of crisis. On June 20, 1765, the assembly passed two pieces of legislation: "An Act for Collecting and Securing the Books of Mortgages, Formerly Kept by the Loan Offices in the Several Counties of this Province" and "An Act for Preventing Frauds by Mortgages Which Shall be Made and Executed after the First Day of January, One Thousand Seven Hundred and Sixty-six."

Yes, on January 1, 1766, all mortgages, which were the basis and backing of New Jersey's colonial currency, had to be recorded with the clerk of the court

Monmouth County Loan Office mortgage book. *Courtesy of the Monmouth County Archives.*

of common pleas, the predecessor to our current county clerks. (It would not be until the New Jersey Constitution of 1844 that these clerks were replaced by elected constitutional officers.) Yet it is still a mystery why those same clerks of the court of common pleas would wait another eighteen years before they began accepting deeds for recording. Besides the recording fees collected by the secretary, there was the issue of the land records themselves. It appears that there was a persistent effort on the part of the Crown to maintain a central recording office, controlled by the provincial secretaries, who were closely connected to the royal governor. Land was the most valuable commodity in colonial America. Only landowners (freeholders) had the right to vote and to hold public office. The more land owned, the higher the office that could be attained. New Jersey was noted for its land title disputes, from the Nicolls grants to the ElizabethTown Bill in Chancery, from the Clinker Lot Right Men to the payment of Quit Rents, the control of the land records was often pivotal in such disputes. Twice before, the king had denied the assembly's request for placing recording offices in each county.

Now the War for Independence was over. The Treaty of Paris was signed. New Jersey was a sovereign state, and on December 14, 1784, a bill was passed in Trenton known as "An Act for the Recording of Deeds and Other Instruments of Writing, Respecting the Titles of Land, in the Several Counties in this State: and for Declaring What Shall be Evidence of

Such Deeds and Other Instruments."[67] The new law noted that recording deeds in the secretary of state's office "is attended with much Inconvenience and Expense to Persons who reside at a Distance," and therefore there has been a "great Neglect in recording."[68] For those who have spent many hours tracking these elusive eighteenth-century titles, this explains quite a bit. It was enough to ask someone to travel by foot or, if lucky, by horse from Little Egg Harbor to the courthouse in Freehold (fifty-five miles—about thirteen and a half hours by horse). But to travel from Cape May to Burlington or Perth Amboy and later Trenton was an onerous burden indeed.

In history class, we all learned about the Enlightenment, the French and Indian War, the Stamp Act, the Intolerable Acts and the Boston Tea Party as events that led to the American Revolution. But it was the overriding quest for self-determination that drove us inexorably toward that conflict. And maybe for New Jerseyans, a very small part of it might have been British interference with and resistance to the decentralization of our land title recording system.

Chapter 5

AFRICAN AMERICAN LANDOWNERSHIP: HOW CAESAR ABRAHAMS OUTWITTED THE SLAVE CODES OF 1714

That no Negro, Indian or Mullatto Slave, that shall hereafter be made free, shall enjoy, hold or possess any House or Houses, Lands, Tenements or Hereditaments within this Province, in his or her own Right in Fee simple or Fee Tail, but the same shall Escheat to Her Majesty, Her Heirs and Successors.
—"An Act for Regulating of Slaves"

When the proprietors, Berkeley and Carteret, attempted to promote colonization in New Jersey, they issued *The Concession and Agreement of the Lords Proprietors of the Province of New Caesarea*, which contained a variety of incentives for the brave "adventurers." This document was, in effect, a solicitation for settlers to come to New Jersey. One of the major incentives was "head rights," the promise of land for each person you brought over. Just for making the trip, each master or mistress would get 150 acres of land, 150 acres for every manservant they brought and 75 acres for every slave, male or female.[69] Having made that long and dangerous trek across the great ocean with his wife, two sons, two manservants, one indentured servant and five black slaves, the master would expect to receive 1,275 acres of land. So the first connection between blacks and landownership in New Jersey was as a land bonus. By 1690, there were over 117 slaves in Monmouth County alone.[70] That represents almost 9,000 acres of land. The incentive to bring slave labor into the province was considerable. The first discrimination against blacks regarding landownership was the fact that white indentured servants, when freed from their obligation (usually seven years), were entitled

to 75 acres of land for their own use. If a black slave was manumitted or freed, they would be entitled to nothing.

The actions taken to regulate slaves and slavery in colonial New Jersey were meant to isolate, marginalize, terrify and terrorize the slave and black populations. The proprietors were saying to black people, "If you can't live as a slave, then you can't live in this land." In 1677, West Jersey asserted its own Concessions and Agreements, which contained the following language: "…being intended and resolved by the help of the lord, and by these our concessions and fundamentals, that all and every person and persons inhabiting in the said province, shall as far as in us lies, be free from oppression and slavery."

So there it is. No slavery in West Jersey. Good news, right? Wrong! The operative words are "as far as in us lies." So they would do their best to avoid oppressing and enslaving people, but sometimes things don't always work out the way they were intended. As proof of that truth, 120 years later, there were 851 slaves in South Jersey. The "no slaves" thing wasn't really a law; it was more like a guideline. In 1776, there was another document that sounded strangely similar, but it didn't apply to everyone, only white males with property.

We hold these truths to be self-evident, that all men are created equal, that they are endowed by their Creator with certain unalienable rights, that among these are life, liberty and the pursuit of happiness.[71]

Slavery was alive and well in New Jersey; however, wherever there were Quakers present, there remained opportunities to overcome this injustice. This was especially evident in Shrewsbury/Fair Haven, where wonderfully cunning and rebellious things occurred in 1768.

When Queen Anne ascended to the throne of England in 1702, she sent forth quite particular *Instructions for Our Right Trusty and Well Beloved Edward Lord Cornbury*, the royal governor of New Jersey (and New York). Among them was an entreaty to do business with the Royal African Company of England so "that the said Province may have a constant and sufficient supply of merchantable negroes, at moderate rates."[72] Now that the stage had been set, the floodgates opened and the queen's imprimatur received, the colonial assembly passed the very first "Act for Regulating Negro, Indian and Mulatto Slaves within the Province of New Jersey" in 1704.[73] It is suggested that the purpose of this act was to address the "daily experience" of thievery by slaves; however, as all good politicians do, the act was embellished to deal

with far more than theft and actually went on to assert a comprehensive slave code to further the heretofore mentioned pattern of terrifying and terrorizing the black population.

> *All Commerce with slaves is forbidden—Five Pounds first offense, Ten Pounds second offense.*

The language is cleverly crafted in a manner that would prevent slaves from amassing any form of personal property or wealth, prevent general intercourse with other people's slaves, limit their access to liquor, enforce the action through the payment of a fine and reward the "Informer" with half the fine. These are the underpinnings of a societal system of oppression that enjoins all the citizens for support.

It also noted that any slave found or "taken up" ten miles or more from his home "shall or may be whipt." If the slave did not possess written permission from their master, the finder got to whip the slave, not more than twenty lashes, and also received compensation of at least five shillings. This section incorporates and indoctrinates the citizenry into the custom of corporal punishment inflicted upon slaves and works to dehumanize the victim, making further punishments acceptable. It is certainly easy to see how this law could be abused by individuals of a cruel or nefarious nature.

> *Any slave from another Province found in New Jersey, will be whipped and imprisoned.*

Limiting the movement of slaves reduced the possibility of organized resistance and simple friendships among the slave population. If a slave family were split up and sold off, it would be very difficult for them to ever consort with one another again. Denying a sense of community makes the slaves more dependent on their master and the home or farm to which they are bound. The finder once again received payment of ten shillings per slave. Simple imprisonment would have served the purpose. The additional act of brutality was included to deter the slave but also to make an example for all other slaves while desensitizing the white populous.

> *A Slave who commits a felony or a murder shall be tried, convicted and executed.*

Capital punishment was visited upon all slaves who commit not only murder, but any other felony as well. No jury of their peers would judge

them; three justices of the peace and twelve white men of the neighborhood would decide their fate.

> *Any Slave stealing six pence to five shillings will receive forty lashes in the "publick Whipping-place."*
> *Any Slave stealing five shillings to forty shillings will likewise receive forty lashes in the "publick Whipping-place."*
> *And furthermore will be branded with the letter "T" on the left cheek.*

This level of cruelty goes beyond the punishment of theft; it is abundantly apparent that these punishments are meant to serve as a sort of theater of submission. The constable received five shillings for the whipping and ten shillings for the branding, and the master had to pay. No doubt this was but the beginning of the slave's injuries. The law goes on to further address the possibility of a squeamish constable or one who might possess a conscience. If the constable refused to administer the punishment, it would cost him forty shillings, and he wouldn't be constable for very long. It would take a certain barbaric disposition to do the job properly.

> *Any slave who shall attempt by force or perswasion [sic] to Ravish or have carnal Knowledge of any White Woman, Maid or Child shall be castrated, imprisoned and executed.*

This would seem to completely and utterly subjugate male slaves to all white women, for fear of being accused of such a crime. Even a persuasive suggestion would be grounds for conviction. And what of the punishment? If the end result was execution, which at this time often included burning at the stake, what further purpose did it serve to castrate the slave? Terrify and terrorize—the constant reinforcement of an inescapable institution of oppression. The castration was done not for the ravisher but to make a point to the entire slave population.

> *Baptism of slaves is not grounds for Liberty.*

Once again, if you can't live as a slave, then you can't live in this land. They would not allow the embracing of Christ as an excuse to release slaves from their bondage.

> *Children born of slaves will be forever after rendered incapable of purchasing or inheriting any Lands & Tenements within this Province.*

This ensures unending generations of slavery and dependence on a slave society. For without the opportunity and access to landownership in colonial New Jersey, there was little hope for survival and happiness. Even if a kindly old master decided to leave property in his will to the slave child who comforted him in his final days, tirelessly attending to his waning health and always presenting an infectious smile in the face of misery, the bequest would be invalidated by law.

> *Any white person who shall knowingly keep or entertain any slave in their house, or otherwise, for more than two hours will pay a fine of one shilling per hour.*

The final salvo: slaves were restricted from socializing with white people on any level. It was complete isolation and ostracization—a nine-point strategy for complete subjugation, segregation and oppression. Even though she promoted slavery in New Jersey, the queen did not have the stomach for this level of incivility. The 1704 law was sent over to England for her approval, and five years later, on October 18, 1709, the Lords of Trade recommended it be disallowed by the queen, as there was one provision "that inflicts inhumane penalties on Negroes &c not fit to be Confirmed by Your Majesty."[74] Any question about which provision that might be?

Not to be dissuaded, the assembly went right back to work on a new "Act for Regulating of Slaves," which passed on March 11, 1714; was subsequently affirmed by the throne; and would be the law of the land for the next eighty-four years. Absent was the unsavory penalty of castration; added were five more reasons why no one wanted to be a slave in colonial New Jersey. Commerce with slaves was still forbidden, and ten miles was reduced to five miles. Felony was defined as "murder, rape, arson or mayhem." Actually, in this section, all a slave had to do was talk about or conspire to commit one of these acts of mayhem, and he "Shall suffer the Pains of Death in such manner as the Aggravation or Enormity of their Crimes (in the judgment of the Justices and Free-holders aforesaid) shall merit and require." The seventh provision is particularly interesting. In order to avoid the inciting of further problems among the slaves, this section ensures that the bad seeds were removed from the community. If your slave violated the prior laws and was executed, you would be paid thirty pounds for a male and twenty pounds for a female. That money would be collected equally from all the other slave owners in the community. This law also mandated that the constable prepare an annual slave list, which included all capable slaves

between the ages of fourteen and fifty years. So, the message was: control your slaves, keep track of them, don't let them fraternize with other slaves and don't help someone else's slave or it might cost you money.

The ninth provision says that if a slave raped a white woman or attempted to strike a white man or woman, he/she could be punished on the spot by any two justices of the peace in whatever way they deemed fit, as long as the slave didn't lose life or limb. The tenth provision addressed the issue of theft, which they had been so concerned about back in 1704. Essentially, the full text of this section stated that the constable could administer a whipping of thirty lashes, with a reprieve of ten lashes from the prior act, if he caught a slave with more than six pence in his pocket. Forty lashes was reserved for stealing more than five shillings, and there was no cheek branding. The constable received five shillings for handing out these punishments. It is frightening to think of the power invested in the constable; he might have been the most feared man among the slave community. Failure to serve on a jury against a slave brought up to a twenty-shilling penalty. Whether a person owned slaves or not, whether he believed in slavery or not, he was forced to buy into the oppression and enslavement of blacks. If another person's slave stopped by another home without permission from his/her master: forty shillings. If the slave never returned or was found dead, the slave's unwitting host was required to pay the value of the slave. Under the old act, freed children of slaves were prohibited from owning real property; in this new version, the assembly recognized that there might be occasions where slaves could gain their freedom. In order to make that a less appetizing option and to ensure the continued subjugation of the black population, slave or free, the law stated:

> *Be it further enacted by the authority aforesaid, That no Negro, Indian or Mullatto Slave, that shall hereafter be made free, shall enjoy, hold or possess any House or Houses, Lands, Tenements or Hereditaments within this Province, in his or her own Right in Fee simple or Fee Tail, but the same shall Escheat to Her Majesty, Her Heirs and Successors.*

Even if you were lucky enough to be freed by your master, and didn't get beaten for having too much money, not having papers or talking about what an awful and ungodly thing slavery was, you still couldn't own a home or any land. It recalls that often-heard expression at closing time in a bar: "You don't have to go home, but you can't stay here." You might have gained your freedom, but you were an island alone in a sea of prejudice. The assembly

might have been too clever by half, for in the law, they invoked the rights of fee simple[75] and fee tail,[76] not remembering that there were other ways to own real property—what are known as estates less than freehold.[77] Two black men, Caesar Abrahams and Samuel Still, would take advantage of that distinction. Finally, and most disturbingly, to end this litany of horrors, the act made a profound statement in its general disregard for black people.

And Whereas it is found by experience, that Free Negroes are an Idle Sloathful People, and prove very often a charge to the Place where they are, Be it therefore further Enacted by the Authority aforesaid, That any Master or Mistress, manumitting and setting at Liberty any Negro or Mullatto Slave, shall enter into sufficient Security unto Her Majesty, Her Heirs and Successors, with two Sureties, in the Sum of Two Hundred Pounds, to pay yearly and every year to such Negro or Mullatto Slave, during their Lives, the Sum of Twenty Pounds. And if such Negro or Mullatto Slave shall be made Free by the Will and Testament of any Person deceased, that then the Executors of such Person shall enter into Security, as above, immediately upon proving the said Will and Testament, which if refused to be given, the said Manumission to be void, and of none Effect.

Now, this might seem like a benefit for the freed slave, since he or she would get an income of £20 per year. But what does this really mean? Any master contemplating the manumission of his slaves would be aware that he would continue to be monetarily responsible for them for the rest of their lives. Even after the master's death, his estate would be required to pay £20 annually; if the administrator or executor refused, for whatever reason, the slave's freedom would be revoked, and he or she would be placed back in bondage. So in reality, the slave was never truly free. Yet before getting to the point of manumission and annual payments, the master must put up a £200 bond, convincing two other freeholders to act as additional surety. Who would possibly take that risk? Maybe family. It was much easier and cheaper to keep slaves in bondage. This provision was the closing brick in the edifice of the impenetrable institution of slavery.[78]

The slave codes were meant to terrify and terrorize blacks, Indians and mulattos. Imagine living a life in which every day would present the potential for corporal punishment. Institutionalized fear was implemented to control the enslaved population and deter free men of color from fraternizing and inciting those in bondage. Yet despite these insurmountable odds, there were slave uprisings in 1734, 1741 and 1774, and the Shrewsbury Quakers had

adopted a very progressive attitude toward slavery as early as 1730.[79] They were far ahead of other Quaker Meetings, voting to ban the purchase and sale of slaves in 1730 and deferring manumission of their slaves through decedent's estates. From 1715 to 1739, 85 percent of the wealthiest 30 percent of deceased Quakers were slave owners. From 1764 to 1780, that number plummeted to 16 percent. Something special was happening in Shrewsbury, and so the specific events of 1793 opened a window to a unique community.

The prohibition against freed slaves owning land would not be repealed until March 4, 1798. Yet five years earlier, on June 19, 1793, two "free negros" would circumvent the law by using a clever legal loophole. Samuel Still, a free Negro, granted a 1,949-year lease for four tracts of land equaling fifteen acres in Shrewsbury to Caesar Abrahams, another free Negro. The consideration for this transaction was £180 up front and "Yielding and Paying therefore yearly and every year...one peper corn if it be lawfully demanded." Although technically not a fee simple conveyance, this lease was fully paid for in advance and would not expire until the year 3742, having the effect of a fee ownership transfer. Yet it did not violate the slave code of 1714. The lease would not be recorded in the county land records until August 12, 1824. It would be a perilous journey for a black man to travel from Shrewsbury to the county seat at Freehold to get his deed recorded in 1793. Under the law, all blacks were considered *prima facie* slaves and were therefore subject to the misapplication of the slave codes and the vagaries of a hostile public. Although there is evidence that Caesar Abrahams was a pioneer in acquiring 2,000-year leases on other lands as early as 1768, this lease is the earliest surviving recorded document of this type and one of the earliest records of African American landownership in Monmouth County. Shown below is the original indenture, which was discovered in the Unclaimed Deeds Collection in the Monmouth County Archives. It is one of the most significant existing African American historical documents relating to Monmouth County.

The recorded copy of this deed can be found in the clerk's office in Deed Book G-3, page 244, but looks nothing like the original. It is typed in the book, revealing that the copy is actually a copy of a copy, since typewriters were not commercially available before 1880 and not in general use until 1895. Every time a document is transcribed, there is opportunity for errors. There is an enormous benefit from being able to examine the original documents when dealing with land transactions. The sale of real estate is a negotiation not recorded, and the final recorded document is the result of those negotiations in a concise narrative form. In this case, the recorded copy includes an opening

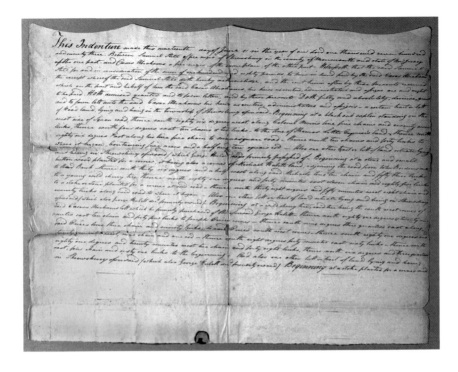

SAMUEL STILL) Release---. This Indenture made this nineteenth day of June
 TO) in the year of our Lord one thousand seven hundred and
CEASAR ABRAHAMS) ninety three. Between Samuel Still a free negro of
Shrewsbury in the County of Monmouth and State of New Jersey of the one part and
Ceesar Abrahams a free negro of the same place of the other part. Witnesseth that
the said Samuel Still for and in consideration of the sum of one hundred and eighty
pounds to him in hand paid by the said Ceesar Abrahams the receipt whereof the said
Samuel Still doth hereby acknowledge and the rent hereinafter by these presents
reserved which on the part and behalf of him the said Ceesar Abrahams his heirs,
executors administrators and assigns are and ought to be paid Hath demised, granted,
and to farm lett in and by these presents doth fully and absolutely demise, grant
and to farm lett unto the said Ceesar Abrahams his heirs, executors, administrators
and assigns. A certain tract or lott of woodland lying and being in the township
of Shrewsbury aforesaid. Beginning at a black oak saplin standing on the west side
of Squan road thence South eighty six degrees west along Colonel Morris line five
chains and seventy seven links, thence south four degrees east ten chains & ten
links to the line of Thomas Little Esquire's land, thence north eighty six degrees
east along his line five chain to Manasquan road, thence north ten chains and forty
links to where it Began Containing five acres and a half and ten squair rod --
Also one other tract or lott of land situate lying and being in Shrewsbury afore-
said (which George Hulet was formerly possessed of-- Beginning at a stone and small

"Release" reference that does not appear on the original and doesn't include Samuel Still's actual mark, as he could not write his name. The reference to the document as a release is erroneous, since it is a lease, a completely different animal. The original looks exactly like what it intends to be—a full fee conveyance. It is an indenture or indented document, which means there are two originals drawn on one large piece of paper, signed and then indented or cut through the middle between the two copies. The seller took the top, and the buyer took the bottom. In the event of a dispute, the parties were brought together and asked to join the two halves of the document. This is the manner in which deeds of indenture were prepared. The copy in the deed book does not reveal the indenture.

There are always several parties involved in the execution of real estate documents: the seller, the buyer, the witnesses and the officer who takes the acknowledgement. Often, those people share a relationship. In this case, the acknowledgment was taken by Samuel Breese, judge of the court of common pleas. He served as a colonel in the Revolutionary War and would manumit his slave Hagar in 1798. He was a well-respected man of the law, and he would handle the estate of Caesar Abrahams when he died in 1797. So, a one-time slave owner befriended a former slave and helped him acquire title to lands by using a somewhat obscure technicality to circumvent the law. Abrahams would have needed a sharp legal mind to formulate such a loophole—that was where Judge Breese came in.

When Abrahams died in 1797, the judge took a careful inventory of all his property, both real and personal.[80] Due to a microfilming error decades ago, the entire inventory is no longer available, but what can be seen is informative. The inventory shows that Abrahams had four properties. He had acquired two acres from George Hulett in 1768, four acres from George Hulett in 1769, four-plus acres from George Hulett in 1774 and five and a half acres from Theophilies Little in 1791—all through the use of two-thousand-year leases. The inventory also listed notes and bonds held by Abrahams from John Borden. The property described in the Samuel Still lease is located on "the road that goes from John Borden's Grist Mill to Red Bank." This free Negro had the ability to lend money to local businessmen. The land

Opposite, top: The original 1,949-year lease between Samuel Still and Caesar Abrahams. *Courtesy of the Monmouth County Archives.*

Opposite, bottom: The 1,949-year lease between Samuel Still and Caesar Abrahams, as recorded in the Monmouth County land records. *Photograph by Heather Paich.*

descriptions in the lease refer to the names of adjoining landowners. If they were adverse to Abrahams owning land, they could have objected. But it appears that George Hulett, John Borden, Theophilies Little, Joseph Price, Michael Hulett, Thomas Little and Samuel Breese had all conspired to allow what otherwise might be objectionable. Something else that stands out in Caesar Abrahams's inventory, amongst the flour barrels, flannel shirts, shovel, stone pots and a cowbell, was five books. Mr. Abrahams was an educated man, and he had a relationship with Judge Breese, who had an extensive library of his own. He had to have developed good relations with many of his neighbors to have pulled this off thirty years before it was legal.

Caesar Abrahams and his friend Samuel Still were definitely not "idle" or "sloathful" people. They understood the importance of landownership and were able to build the friendships necessary to make it a reality for them even though the laws in New Jersey forbade it. They were courageous, resourceful, astute and determined, and they beat the system. In 1834, Samuel Breese's executors would sell those four lots to Quaker Jacob Corlies Jr. Four years earlier, that same Jacob Corlies and his wife, Hannah, had sold eight acres of land on Rumson Neck to Jacob Brown, a "Coloured Man" and son-in-law of Samuel Still. Jacob would use that land to build a free African American community in Fair Haven, with a church, a school and a meetinghouse, and lead his friends out of the darkness of slavery and into the promise of the future.

FAIR HAVEN WAS A SAFE HAVEN: JACOB BROWN'S DREAM

I believed that merit was superior to birth, or even to the color of a man's skin.
—Dr. James Still, "Black Doctor of the Pines" 1877

Ole Jake Brown with bicycle and accordion. *Courtesy Asbury Park Press.*

I first met Jake Brown in the Monmouth County Hall of Records on the pages of various deeds. Jake owned a parcel of land on Brown's Lane in the borough of Fair Haven. I was retained to perform a title search on this property in 1991, as he was anticipating the sale of his homestead because he could no longer manage it. Jake was the great-grandson of the man who bought this land and built a home on it in 1830. Jake had been born in that house, one of fifteen siblings, a century earlier. His great-grandfather was also named Jacob Brown. Laboring through the conveyances, estates and genealogy of this large family, it was apparent that this land was the foundation of something noteworthy.

His ancestor Jacob Brown, was a "Coloured Man," as noted on the 1830 deed, and there was evidence of a free African-American community centered around his homestead. This land was subdivided for the purpose of sale to other blacks and the dedication of

lands for a free African American church, meetinghouse and burial grounds. Despite the climate of oppression, this insular enclave would grow and prosper during the first half of the nineteenth century, in the shadow of New Jersey's Act for the Gradual Emancipation of Slaves in 1804—an act that emphasized the "gradual" much more than the "emancipation." This appeared to me as a story yet untold and one that needed to be shared.

The Shrewsbury Quakers

The Rumson Neck Peninsula and Shrewsbury, of which Fair Haven was a part, was chiefly settled by members of the Religious Society of Friends (Quakers). Although they would become leaders in the abolitionist movement, initially, most of the Quaker households in Shrewsbury possessed slaves. This was the source of a constant dilemma for them. Not because they thought that blacks were their social or intellectual equals, but because the institution of slavery was violative of their religious laws.[81] It was a matter of conscience. In 1688, the Germantown Quakers wrote the first antislavery petition, and in 1730, the Shrewsbury Meeting agreed to oppose the importation of slaves in New Jersey.[82] With the example of prominent Friend John Lippincott in 1720, the Shrewsbury Quakers began to embrace the practice of manumission by will.[83] This was no small sacrifice, given the loss of labor, valuable asset, and the responsibility and burden on the estate and his heirs of complying with the 1714 slave codes in providing the appropriate bonds and payments to the freed blacks. Of course, the Quakers, being the best sort of masters, if fully following the tenets of their religion, usually employed the manumitted slaves and let them live on their farm or plantation.

In 1750, the Quakers would be struck by a crisis. As pacifists, they could not and would not support the growing hostilities against the French and Indians. They felt equally vexed by levying taxes to support the war effort in the assembly and local government. In both New Jersey and Pennsylvania, where the Quakers had wielded strong political influence for decades, they were forced to gradually resign their offices and give up the authority as a matter of conscience. The Quakers now turned to the abolition movement with a sense of purpose. It was agreed at the yearly meeting in 1758 that the Friends would actively oppose the practice of slavery itself, along with the trade in human flesh.[84] Many of the monthly meetings actively

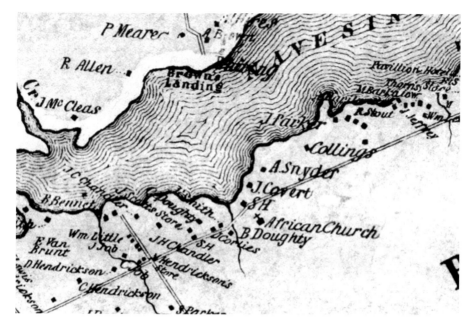

An 1851 Jesse Lightfoot map of Monmouth County showing Fair Haven and African Church. *Courtesy of the Monmouth County Archives.*

pursued the manumission of their members' slaves, but none as zealously as the Shrewsbury Meeting. They formed a special committee to review all instances of slave purchase and sale by any member, fully expecting the transgressing Friend to make full amends by arranging for the freedom of all slaves. This is not to say that the Shrewsbury Quakers drove their slaves into the streets. Most established some form of gradual emancipation, often holding their slaves in bondage until the age of thirty or thirty-five. But what they did do was obtain written commitments to manumit all slaves sometime in the future. By 1776, only two Shrewsbury Friends refused to manumit: Josiah Parker and John Corlies. Eventually, Parker came around, but Corlies was unconvinced. In December 1778, John Corlies was disowned by the Shrewsbury Friends.[85]

By the time the Gradual Abolition Act of 1804 was passed, every slave owned by a Quaker had long since been manumitted. The magic decade for slaves in Monmouth County was the 1820s. The 1820 census shows that there were 982 free blacks and 1,248 slaves in Monmouth that year. The 1830 census shows a staggering shift to 2,072 free blacks and only 227 slaves, and the total population of blacks had increased.[86] That represents an 82

percent rate of manumission. In Shrewsbury that year, there were only 12 male and 12 female slaves, but there were 294 free blacks. That was a 92 percent emancipation rate, as compared to the rest of the state's 88 percent rate, with northern Jersey at 83 percent. However, a careful review of the 1840 census discloses the fact that not only did many of those free blacks not own real estate, but many were still living with their former masters. In the 1860 census, fifty-six years after the Abolition Act of 1804, there were only 38 landed blacks in Shrewsbury out of a population of 456.

This data punctuates the unique quality of the Fair Haven enclave. There was a similar community being formed across the river in Middletown (Riceville) shortly after Fair Haven, but the stark contrast was the lack of landed free blacks. That is not to say that landownership was essential to form a sense of community; there were plenty of non-landed members of the Fair Haven enclave. But the fact that the community did have a physical permanence about it is that much more extraordinary. This can be credited, in large part, to the abolitionist ground clearing that was done by the Shrewsbury Friends beginning in 1730.

The Enclave

Approximately 70 percent of all blacks in Monmouth County were still enslaved in the year 1810, six years after the passage of the Gradual Abolition Act.[87] The 1790 census shows that there were 1,749 blacks in Monmouth, of which 353 were free.[88] While half of those free blacks lived in Shrewsbury Township, there were still 150 to 200 slaves in the township as well. It was around this time that one free African-American would set the stage for a black community at Fair Haven.

Samuel Still: The Patriarch

Samuel Still, a "free negro," would figure prominently in the Fair Haven community in later years, but he first appears in the land records on June 19, 1793.[89] On that day, Samuel Still delivered a long-term lease to Caesar Abrahams, a fellow "free negro." Although the descriptions are not specifically

located, the four tracts of leased land were located on the Rumson Neck Peninsula. That deed would not be recorded until 1824, for reasons previously discussed. Samuel Still and Caesar Abrahams appear to have found a friend in George Hulett, who sold them land long before it was legal to do so. The earliest recorded conveyance into Still is dated September 19, 1803, for eight acres of land on Rumson Neck from Quaker Thomas Hance. This tract also adjoined lands of another Quaker, Benjamin Corlies. These free men of color, Still and Caesar Abrahams, were literally being socially insulated by the landholding Quakers directly adjacent to their homesteads and farms.

Samuel Still went on to become one of the great benefactors of the Fair Haven enclave, and his daughters, Ann and Catherine, would marry Jacob Brown and Anthony Quero, respectively, two other prominent members of the community, on September 29, 1828 and December 5, 1836. Samuel Still married Elizabeth Clayton on March 10, 1832, but his wife appears as Abigail on later deeds beginning in 1836. Given their marriage dates, it seems neither Ann nor Catherine could be Elizabeth's daughters.

From 1793 to 1866, Samuel Still acquired over twenty-eight acres of land on Rumson Neck and profited by $1,786.57 in land sales. Still's elevated position within the enclave is evidenced by his philanthropic conveyances of land for the benefit of the community at large. The first was a gift of land on Brown's Lane for the purpose of a free African American meetinghouse and school in 1842.[90] This was a small lot, sixty-six feet by sixty-six feet, but was still a starting point for a young community. The trustees of the church were Anthony Quero, Charles Jobs, James Davis, John Brooks and Elijah Stillwell. This church lot was part of a larger eight-acre plot of land originally acquired by Still's son-in-law, Jacob Brown, which would become the focal point of the community.

In 1850, Still provided another plot of land for a free African American schoolhouse. It is possible that in those few years, the enclave had outgrown what had to have been a small building on the original lot. In this deed, Still set forth the trustees for the schoolhouse as Anthony Quero, Charles Jobs, Abraham VanDerVeer, Isaac Wales, Alfred Ludlow and Thomas Stillwell, the latter three being residents of Middletown across the Navesink River. In 1866, he provided land to the Methodist Episcopal Mount Zion Church at Rumson near Brown's Lane in Fair Haven. The trustees set forth therein were Benjamin Richardson, Silas Holmes, Robert Richardson, Anthony Sylvester, George W. Johnson and Philip Augustus.

Earlier in 1835, just as the enclave was forming, Richard White, a colored man, died seized of a house and property on the Navesink River valued at

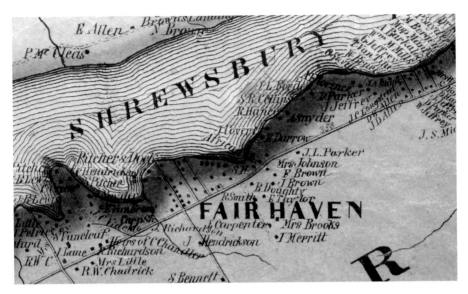

An 1860 Beers map of Monmouth County depicting the south shore of the Navesink. *Courtesy of the Monmouth County Archives.*

$388.00. (There is no recorded deed into White.) Amelia White bought it from the estate and immediately sold a half interest to Samuel Still for $194.00.[91] A year later, they sold it for a profit of $87.00.[92] This is undoubtedly an example of Samuel stepping in and helping a community member to retain her familial home, and managing a profit from an otherwise difficult situation. The land records are replete with examples like this. When viewed in their entirety, it presents a broad mosaic of interaction, reliance and support. The protection of the Quaker community would gradually recede as the century progressed, and it was evident that these former slaves could rely only on one another, regardless of the charity of the Friends. Samuel Still not only set an example by assuming the position of elder statesman and facilitating the education and faith of the community but he also married his daughters into the community, enabling his bloodline to live on into future generations.

Another important bit of information revealed by the records of Samuel Still's land dealings is found in a deed from 1861.[93] The description in this deed to Joseph Holmes refers to a "burying ground" located near "Quero's Lot & Church, beginning at the northeast corner of Anthony Quero's lot thence running southwardly along Quero's Lot & church lot, and Johnson's lot and along the west side of the burying ground to Edward Brown's Lot." Although the description lacks specificity, since the locations of Quero's lot, the church lot and Edward Brown's lot are well known, the burial ground

must be located on Lot 22 in Block 62, as shown on the current tax map of Fair Haven. Lot 22 now encompasses all of what was formerly the 1842 free African American meetinghouse lot.

In 1998, this would become newsworthy because the remaining descendants of the Fair Haven African American enclave were attempting to preserve the burial site.[94] There were whispers of stolen gravestones and moved bodies, some of which might have wound up in the White Ridge Cemetery in Eatontown. The matter went to the Superior Court under the case of *Harris v. Borough of Fair Haven, 317 NJ Super 226* (1998).[95] The court ruled against the descendants and in favor of the private landowner, citing the absence of legal precedent to take such action:

> *There is no question, and plaintiff is rightfully concerned, that it is something of a disgrace that ancient cemeteries in the State of New Jersey—and presumably elsewhere—have either fallen into disrepair or have entirely vanished from sight. Our Legislature recognized this at the time it adopted the "Historic Cemeteries Act."*

It is true that the legislature did recognize it—"The Legislature finds that within the State of New Jersey, there are many historic cemeteries… that such cemeteries serve to remind us of our cultural and historic heritage…"—but the legislation passed in 1983, N.J.S.A. 40:10B-1, provides little, if any, assistance for preservation and fails to address the rights of the interred and their descendants and their priority, if any, with regard to private property rights.

Brown's Lane: The Enclave Center

On March 20, 1830, Quakers Jacob Corlies Jr. and his wife, Hannah, conveyed a 7.89-acre tract of land on the south side of River Road on Rumson Neck to African American Jacob Brown for the sum of $244.50, as recorded in Deed Book H-6, page 603. This deed would not be recorded until twenty-five years later. The grantor in this deed, Jacob Corlies Jr., was born on April 1, 1755, and shared a common great-grandfather, George Corlies, with John Corlies, who was disowned by the Shrewsbury Quakers in 1779 for refusing to manumit his slaves. Jacob Jr. married Hannah Usteck on May 20, 1824, in Christ Church at age sixty-nine. He died on Christmas

Day 1841 at the age of eighty-six. During his lifetime, he was a friend to the free blacks. His family had been on Rumson Neck since the 1670s and were slave owners at one time. Jacob Jr. not only sold land to free blacks but also lent money to and served as the executor for some of the community members, including oysterman John Williams in 1821. Corlies's name appears on many legal documents as a witness for transactions involving enclave members. When he conveyed that 7.89-acre parcel (what is known today as Lots 11, 13, 15.01, 15.02, 15.03, 16 through 28, 78 through 80 and 82 through 84 in Block 62 and Lots 8 through 10 in Block 65 on the tax map) to Jacob Brown, he set in motion a chain of events that would give birth to a community of free people who only knew the history of oppression. Corlies was truly a "Friend" to this community.

Jacob Brown would purchase much more real estate in his life, but this particular piece was certainly the most important. He would subdivide this property and sell portions to Anthony Quero, Samuel Still and other members of his family and the enclave. The first free African American meetinghouse and schoolhouse would be built on his lands. Jacob Brown and his family would be integrally involved in the development and leadership of the free black community in Fair Haven. Jacob and Ann (Still) Brown would have three children: Jacob S. Brown or Jacob Brown Jr., who would marry Euphemia Jobes, the daughter of one of the most successful black families in the enclave; Edward Brown; and Catherine Brown. All three remained in Fair Haven and had children of their own, settling on Brown's Lane on one of the lots that Jacob subdivided for them. The road that serviced all of the lots subdivided by Jacob Brown would come to be known as Brown's Lane. On that lane would be a free African American meetinghouse, school and, later, an AME church and burial ground. Over time, the church would factionalize, but the splinter churches would remain in proximity to Brown's Lane. This was the hub of the community. Jacob Brown lived on Tax Lot 16 in a house that remained standing until the mid-1990s, when the new owners knocked it down and built three new homes. Although the community wasn't restricted to Brown's Lane (Robert Jobes was over on Fair Haven Road, Charles Jobes lived on De Normandie, Alfred Jemison was on Hagger Lane, Thomis Coy lived on Gillespie and, of course, Esther Manning had her store at the corner of River Road and Van Tine Street), the soul of the community resided there.

Anthony Quero lived on Tax Lot 15.03. There is no recorded deed into him for it; however, all the adjoining deeds call to his lines and corners. He was married to Catherine Still, daughter of Samuel Still and sister of Jacob's

first wife, Ann. At the age of twenty-eight, Anthony was freed by Edmond Throckmorton of Middletown on January 7, 1832.[96] Ten years later, Anthony Quero would be the first named trustee of the free African American church and schoolhouse.[97] This house of worship would form the nucleus around which the free African American community in Fair Haven would evolve. In 1850, Quero would again be the first named trustee, in a deed from Samuel Still, of the free African American schoolhouse.[98] Quero would show up fifteen years later as a trustee for the first African Methodist Episcopal Church of Riceville, in a deed for land in Middletown.[99] Then, in 1861, he was listed as one of three trustees of the African Methodist Episcopal Bethel Church at Fair Haven, in a deed for land in Shrewsbury on the Navesink River.[100] Anthony Quero was obviously recognized as a spiritual leader, someone who could be trusted with the affairs of the church and community.

Quero also owned two pieces of salt meadow in Fair Haven, both purchased from Jacob Brown. The latter was never evidenced by a deed of record but was referenced in other deeds. He sold them in 1868 and 1873 for a combined consideration of $4,750.[101] Quero married Catherine Still on December 5, 1836, and produced one child, Serena Ann Quero. Serena Ann would later marry James Polhemus. The couple would have two daughters, Emma Hicks and Mary E. P. Reevey.[102] He would remarry later in life to a woman named Lavinia. No estate was found to be filed for Anthony Quero in the Monmouth County Surrogate's Office. Deed records show he was alive as late as 1873. Anthony Quero was not a large landholder in the community; however, the mere fact that he was purchasing real estate at the same time that his brethren were still appearing as assets in inventories is significant. In 1840, thirty-six years after the passage of the Abolition Act of 1804, there were still eighty-five slaves in Monmouth County. Anthony Quero was probably one of the last of the community to gain his freedom, and yet he appears to have wasted no time in becoming one of its most dynamic and influential figures, despite the fact that he could not sign his own name. In fact, an examination of the numerous land transactions that occurred with and between the various community members reveals that many of the other men could not sign their names, but that did not stop them from working to become full and equal members of society. And although there were still eighty-five slaves in Monmouth County in 1840, at least ten young descendants from the Fair Haven community would enlist as Union soldiers and fight in the Civil War.

Conclusion

When I first came to this project, it was through the land records and the revelation that there was a corner of New Jersey that, for a time, did not subscribe to the philosophies of our southern cousins, at a time in our history when it took real courage to move against the tide. The idea that men like Anthony Quero and Robert Jobes could be analogous to livestock on one day and owners of land and homes of their own a short time later must have seemed remarkable to them. To move so completely out of bondage to a polar extreme makes one wonder how Anthony and Robert felt about it. This shouldn't be mistaken for some Pollyanna *view of life in antebellum New Jersey. Arthur Zilversmit notes Jeremy Belknap's comments in 1790 on the conditions for blacks in Massachusetts, a far more affable state in its regard, that "many of them are in far worse condition than when they were slaves, being incapable of providing for themselves the mean of subsistence." But that is just the point at Fair Haven. They had their freedom and opportunity, and some, like*

A photo of a Brown family reunion. Jake Brown can be seen seated in the center of the photograph. *Courtesy of Robert Ender.*

Jobes, Brown and Still, seized the opportunity and savored the sense of accomplishment and fulfillment acquired only through personal achievement and control over one's own destiny. Some, like Richard Smock, would not fare as well, while others, like Quero, might have reaped their rewards from moral victories and spiritual fulfillment.

Ole Jake Brown passed away on July 14, 1994, just short of his 100th birthday. He was a proud and happy man who was celebrated throughout Fair Haven. In 1987, Jake was named the grand marshal of the town's 75th Anniversary parade and awarded a brand-new Schwinn Racer bicycle (his preferred mode of transportation).[103] The Brown homestead is gone, but not the spirit of Brown's Lane and the enclave of free African Americans that flourished there. This work merely pokes a pinhole in the shroud of time that has separated us from the rich history of a place that was a safe haven for people of newfound freedoms.

Chapter 7

PROPERTY OWNING PROPERTY: THE JOBES HOMESTEAD IN FAIR HAVEN

As the last northern state to end slavery, New Jersey's race relations are especially provocative. It is important to know more about how blacks and whites, though divided by the chasm of race, interacted in a developing society; it is also important to know more about how blacks, once freed, used the symbolic and concrete advantages of freedom.
—Clement Alexander Price

There is a house that stands on a tree-lined street, in a quiet neighborhood along the southern shore of the Navesink River, that conceals an extraordinary story within its black-and-white façade. It is the oldest existing homestead built by a freed slave in Monmouth County. This two-story colonial with Greek Revival elements belies its original form, having additions on both the north and south sides of the primary structure. The original structure was limited to one story with a large attic; the second floor was added on at a later date. Exterior and interior architectural examination provides evidence that the home could date back as far as 1800. That date coincides with two mortgages recorded in 1801.[104] These two mortgages reveal that former slaves, Richard and Hager Smock, were the owners of two parcels of land totaling eighteen and a half acres, which includes most of the land located between Fourth Creek and the Westerly sideline of Fair Haven Road in Fair Haven, New Jersey.

Hager Smock was manumitted on August 21, 1798, by her former master, Samuel Breese. On that day, she appeared before the overseers of the poor

The Jobes Homestead on Fair Haven Road. The original one-story structure is on the left (the second story was added in the twentieth century). *Courtesy of Randall Gabrielan.*

Street sign at the corner of Haggers Lane and Fair Haven Road. *Photograph by Heather Paich.*

and two justices of the peace, one named John Smock, and was found to be "sound in mind and not under any bodily incapacity of obtaining support" and between the ages of twenty-one and forty years old.[105] The condition of slavery was not a private matter. Although a slave was the property of the owner, there was a strict set of laws regulating the institution going all the way back to 1704. The manumission of a slave concerned every other free white man in the community. Regardless of the good intentions of a slave owner in emancipating his slaves, the latter could not be a public burden. If they were perceived to be such, then manumission would not be allowed, and the slave owner would continue to be responsible for his "property" unless he posted a $500 bond with two sureties who were "inhabitants and freeholders" of the county.[106] Good luck finding two landowning neighbors willing to serve as surety on your bond.

Richard Smock is listed on the aforementioned mortgages as a yeoman and is not identified as a black man. This information is revealed in his estate proceedings fourteen years later. No manumission papers were found, but it is assumed he was a former slave because there are no deeds recorded into him or Hager for the property that was mortgaged. Mortgages are recorded by the lenders. Deeds are recorded by the buyers. A trip to Freehold for a black man in 1800 to record his deed was fraught with peril. "Black men, in contemplation of the law, are *prima facie* slaves, and as such are entitled to be treated as such."[107] In 1790, 44 percent of the blacks in Shrewsbury were free. At that same time, only 2 percent of blacks (12 out of 639) in Freehold were free.[108] The fifteen-mile trip to the courthouse in Freehold might have been akin to crossing the Mason-Dixon line sixty years later. Freed blacks had only acquired the right to own real estate two years earlier, with the revision of the New Jersey slave code in 1798. That same code required that free blacks traveling outside their home county carry a certificate of freedom signed by two justices of the peace. It also mandated that slaves found more than ten miles from their master's home, or seen outside after 10:00 p.m. without their master's permission, were subject to being whipped by the constable.[109] One can only imagine the difficulties a black man might endure on such a journey.

The good news is that the Smocks' white neighbors, Zephaniah Chadwick and George Woolley, were willing to lend them "100 pounds York currency" and "127 dollars and fifty cents," respectively, in order to build the family homestead. Each mortgage consists of three one-year notes, with no interest charged by Chadwick and only one year of interest charged by Woolley. These were very favorable terms for any person. Chadwick had actually lent Richard money on the first note six months earlier in December 1800, before

the mortgage was signed or recorded. These documents reveal a unique relationship between these recently freed slaves and their white benefactors. Two years prior, Hager had been property; now she was a property owner.

It is a mystery how the Smocks acquired the land. Maybe the deed was held off record, or maybe it was a two-thousand-year lease like the one obtained by Caesar Abrahams. It is possible that Richard could have obtained the property through a devise under an estate. This would explain the absence of a deed. The Smocks might have purchased these two tracts of land from Zephaniah Chadwick and George Woolley. In 1801, there were very few institutional mortgage lenders, and even fewer who would extend credit to a black man. It is most likely that Chadwick and Woolley "took back"[110] mortgages on land that they sold to Smock. This was the common practice of the day. The descriptions in both mortgages call to other lands and corners of Chadwick and Woolley, indicating a connection with the premises. Unfortunately, the euphoria would be short-lived. By 1809, Chadwick brought suit to foreclose, and by February 1814, the sheriff would sell the land, as Richard had died. Hager disappears from the records. When sold in 1814, the property was valued at $323.50. However, the land was sold at sheriff's sale and most likely was bid much lower than its actual value.

These lands are designated on the current tax map of the borough of Fair Haven as all of Lots 1 through 14 in Block 26 and Lots 1 through 20, 55 through 69, and part of 72 in Block 27. It was probably good, fertile land and very attractive to oysterman Robert Jobes, who in April 1814 purchased four acres of this land at the sheriff's sale without a mortgage. Richard Smock died prior to July 12, 1812, leaving an estate that listed no personal effects in his inventory and debts totaling $103.50 owed to Brittain Bennet, one of the successful bidders at the sheriff's sale. Taber Chadwick applied for letters of administration and proceeded to petition the court for the sale of all lands held by Smock. Interestingly, the estate listed Smock as being late of Shrewsbury and New York, but there is no mention of his wife, Hager. A lasting legacy to the Smocks is the small road named Hagger Lane, which runs along the premises from Fair Haven Road, along the northerly sideline of the Robert Jobes four-acre tract. The homestead is located at the corner of Fair Haven Road and Hagger Lane on Lot 63 in Block 27.

Robert Jobes was manumitted by Samuel Stephenson of Middletown on March 12, 1808.[111] It is important to note that just six years after being released from bondage, Robert amassed the cash and the gumption to buy this land and establish himself in a business to support a wife and nine children. To place this in context, at this same time, deceased slave owners

Robert Jobes's manumission certificate, as recorded in the Monmouth County Clerk's Office. *Photograph by Heather Paich.*

were still devising/leaving their slaves to their heirs as valued property. One such family placed a value of ten dollars on black men (John and Abram) and twenty-five dollars each for a woman named Ellen and a boy named Oliver.[112] Manumitted slaves owning land was an anomaly, and yet it appears that Fair Haven provided special opportunities. Robert married Euphemia and had nine children: Robert Jr., Charles, Hagar, Rosanna, Jane, Sarah, Mary, Elizabeth and Shepherd. His son Robert Jr. married Famy/Fany and had three children: Shepherd, Mary Elizabeth and Euphemia. His granddaughter Euphemia would eventually marry Jacob Brown of Brown's Lane, which would become the epicenter of the free black community in Fair Haven.

Robert Sr. enjoyed a certain amount of success, and when he died in April 1837, he left his land and an inventory worth $167.87. The inventory consisted mostly of oyster and clamming equipment. He was an oysterman by trade and passed his skills on to his son Charles Jobes. Oystering was an important and lucrative business on the Shrewsbury River that had been going on since the early part of the eighteenth century. By 1840, oystermen had learned how to seed and farm oysters in the Navesink and Shrewsbury Rivers. Charles Jobes took advantage of this apprenticeship.

The parcel of land that Robert Jobes acquired from the Smock estate in 1814 was destined to be on the main road of commerce in Fair Haven. The road formerly known as Van Tine Street and Pearl Street would lead from the center of town to the dock where, one day, steamships would come in and the Fair Haven Hotel would stand. Charles Jobes purchased a small lot of land from his father in 1836 and later acquired the rest of the property from his father's heirs in 1859. Charles married Ester/Esther/Hester A., and they had four children of their own: Isaiah/Isah, Robert, Mary (Parker) and Albertina, three of whom died tragically.

Their daughter Albertina died very young on September 20, 1853, at the age of two years and six months. In 1845, a steamship company started providing service from Fair Haven to New York. Its most famous steamer was named *Albertina* and today is incorporated into the Fair Haven borough seal.

Robert Jr., as he was referred to, died on January 22, 1866, only three years after his father, at the age of twenty-one years, seven months and eight days. He, too, was an oysterman, and he left an estate valued at $826.41. This was a considerable estate for any twenty-one-year-old man, much less a black man, in 1866. His estate also shows that he had lent money to several other members of the Fair Haven community, including Alfred Ludlow ($19.62), Alexander Snyder ($75.93) and A.H. Brower ($146.00).

Isaiah Jobes, the younger son of Charles, would run into some legal troubles shortly after the Civil War, various indebtedness that required the issuance of writs of execution and a levy on all his assets. He drowned in the Navesink River on November 11, 1887, at the age of forty years, ten months. The coroner conducted an inquest into his death, along with that of another "colored man," William Johnson. Johnson was the son of George Johnson, who lived on Brown's Lane.[113] The testimony of the other two passengers on board the boat stated that they were crossing the river after work at 5:30 p.m. when the boat began to take on water. They claim that Isaiah and Johnson became frightened and jumped out of the boat, but neither could swim. The two survivors were rescued and claimed they could not save Jobes and Johnson, whose bodies washed ashore the next day just east of Oceanic. It does seem strange that a person who lived on the river all his life, and whose father was an oysterman and ship captain, would not know how to swim.[114] However, Isaiah did not follow in his father's footsteps; the 1870 and 1880 U.S. censuses list him as a farm laborer and still living with his mother, Esther Manning, in the Jobes Homestead.

Charles Jobes was an oysterman, sloop captain, storeowner, Freemason and entrepreneur. He regularly went back and forth to New York City in his

STUB.

"Stub" to be kept by Physician.

REPORT OF DEATH.

1. *Full name of deceased* Isah Jobes

2. *Age* 40 yr 10 m
3. *Color* Blk *Occupation* Labor
4. ~~Single,~~ married, ~~widow or widower.~~
5. *Country of birth* U.S.
6. *Last place of residence* Fair Haven

7. *How long resident in State* Lifetime
8. *Place of death* Shrewsbury River

9. *Father's name* Christ Jobes
Country of birth U.S.
10. *Mother's name* Esther Jobes
Country of birth U.S.
11. *Date of death* Nov 11 188 7;
Cause—Primary Accidental
Drowning
Cause—Secondary R. S. Smith
Coroner

Mode of death
(Clinical notes on opposite side.)
Length of sickness
Undertaker R. R. Mount

Left: Coroner's report on the death of Isah Jobes, who drowned in the Navesink River in 1881. *Courtesy of the Monmouth County Archives.*

Opposite: An 1860 Beers map of Monmouth County depicting Fair Haven. *Courtesy of the Monmouth County Archives.*

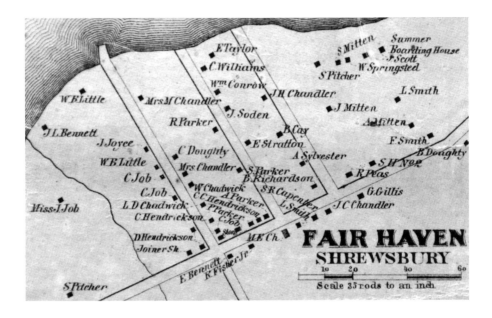

sloop, which was the fastest and most common form of travel. This was also the biggest market for oysters. Clams and oysters would fetch twelve cents per one hundred and one dollar per one thousand. The trick was to get them to market on time. The trip normally took four days by sloop, much faster than the path overland. But the currents in and out of the Sandy Hook Inlets could be treacherous, and one had to rely on the wind. The currents were so strong that several times the inlets closed up completely. The path between Sandy Hook and the Highlands was not originally navigable. This presented a constant challenge to the sloop captains, who were admired as very tough and courageous men.

The sloop *Lafayette*, which was owned by Charles Jobes, was an invaluable commodity that placed him in the center of three lucrative professions: (1) oyster and clam farming; (2) transporting produce and goods to the New York market and (3) purchasing fashionable New York goods for resale on Rumson Neck. Charles Jobes's nine-page estate inventory lists an inordinate amount of goods that he could not possibly have used himself, including numerous chairs, beds, bedding, linens, carpeting, cloth, etc. He also possessed three overcoats, one pair of kid gloves, one silk handkerchief (and numerous ones made from other cloth), one pair of white gloves, three pairs of dress boots, one revolver, stair rods for carpeting and feather beds. Charles Jobes enjoyed a very comfortable lifestyle.

Charles saw opportunities in these trips and augmented his income by taking passengers and produce to New York. Once there, he used some of the money to purchase the items that could be obtained only in the city. He brought these wares back and opened a store at the corner of Fair Haven Road and River Road. Even after his death, his wife, Esther, continued to run the store for many years under the name of Esther Manning until 1902.

No doubt, the advent of the steamship cut into his enterprise, but he appears to have managed a considerable degree of success. Charles was worldly and educated. He signed his name, not his mark, on all documents, unlike most of the other blacks—and also many of the whites at that time. A review of the grantor index in the Monmouth County Clerk's Office for the years 1836 to 1859 reveals a fluid level of capital, having engaged in twenty-two separate transactions during that period. On March 21, 1859, Charles purchased the store lots for $2,200 from Samuel Carpenter. Carpenter took back a $1,200 mortgage, and Jobes mortgaged another property for an additional $850. At this point, he was heavily leveraged—and unaware that he would not live another four years.

It is at this time that we learn something more of the character of Charles Jobes. With his silk handkerchiefs, kid gloves, dress boots and revolver tucked in his waistband, Charles must have cut quite a figure. He had money, success and the admiration of his peers. He was a member of the Masonic Lodge. In 1842 and again in 1850, he appears as a church and school trustee on several deeds. He was obviously a respected member of the community. But a bump in the road came along in September 1860, when Gordon Sickles, overseer of the poor, came to call. It seems that Charles was responsible for impregnating a girl by the name of Electy Parker, and the town required him to give a $1,500 mortgage as security for the upkeep and care of the child born out of wedlock.[115] The mortgage was finally cancelled in 1882, sixteen years after his death and twenty-two years after Electy gave birth.

Charles died on July 5, 1863, leaving an estate that fills nine pages of inventory and is valued at $1,293.67, exclusive of real estate. He owned the sloop *Lafayette*, a skiff, a scow and an interest in a pleasure sailboat. He also held notes in the amount of $37.39 for William Jackson and $20.18 for the AME Zion Church of New York. His son Isaiah acquired Lot 61 in Block 27 in an odd sort of transfer with Esther, who had since remarried one Moses Manning. Robert Jr. died three years later. In 1869, the house and lot at 70 Fair Haven Road was sold to William Conover. Finally, in 1902, the store lot and other real estate are lost to tax sale. Esther died on April 8, 1908, leaving Mary E. Parker as her sole heir at law.

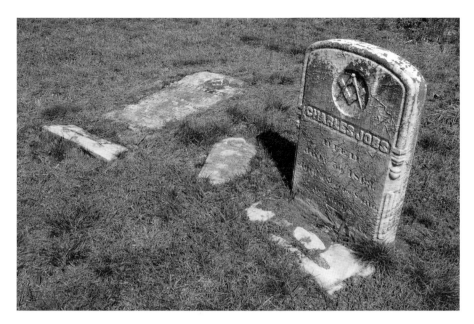

Headstones for Charles, Robert Jr. and Albertina Jobes at the White Ridge Cemetery in Eatontown. *Photograph by Heather Paich.*

Today, Charles Jobes is buried at the White Ridge Cemetery on Wall Street in Eatontown. His plot is located near the office building in the center of the cemetery, near the monument. The bodies of Albertina and Robert Jr. lay alongside him, with his daughter in the middle of the two men. The men's headstones are the same: white marble stone, three feet tall, facing south and each with the Masonic symbol carved at the top of the stone. Albertina's headstone reads:

> *The icy hand of death*
> *Touched this tender flower*
> *And bore away its breath*
> *Within a fleeting hour*

Both Robert's and Charles's headstones have epitaphs or inscriptions on the bottom but are not legible. Robert Jr.'s and Albertina's headstones have been knocked over and lie on their backs. There remains a mystery here: how does someone who died in 1863 get buried in a cemetery that did not exist until 1886? When compared with other headstones in White Ridge, it

is apparent that they are no older than eighty or ninety years. These three bodies were moved to this cemetery some time after the turn of the century. Unfortunately, the administrators of the cemetery have no information regarding this question. Is it possible that they were moved from the "old negro burying ground" on Brown's Lane? That is another story.

The Smocks and the Jobeses lost no time in taking advantage of their newfound freedom. The complexity of these land transactions and the value of the property indicates that they were educated and prepared to embrace the opportunities with courage and determination. It is obvious that there were intricate relationships between the blacks and whites in the community that had been forged in prior years. The white house with black shutters stands today at the corner of Fair Haven and Haggers as a testament to those unique relationships. Unfortunately for Smock, that ended all too abruptly, the uncertainty of life being what it is. The Jobes family, despite their various misfortunes and bumps in the road, would become one of the most successful free black families in the community and in the whole of Monmouth County on multiple levels—socially, commercially and religiously. For some in Fair Haven at the turn of the nineteenth century, the "chasm of race" was not nearly as broad and daunting.

Chapter 8

HOBOKEN: THE LAST ATTAINDER

*The sober people of America are weary of the fluctuating policy which has
directed the public councils.*
—James Madison

It was a warm and muggy morning on August 19, 1779, as Major Henry
"Light Horse" Harry Lee (father of General Robert E. Lee, CSA) and
three hundred American soldiers made their way across the Salt Marsh
at Paulus Hook to attack the British fortifications on the Hudson River. It
was a daring raid that would be fought only with bayonets and in the dark
of night, in accordance with General Washington's explicit orders.[116] They
would advance in three columns up to their waist in muck and mire, getting
lost and turned around, before they would successfully descend upon the
British position, killing 50 and capturing 158 while suffering only 2 killed
and 3 wounded Americans. This would be the last major engagement of the
Revolution to be fought on New Jersey soil. Washington and his men would
retire to Jockey Hollow/Morristown to endure the coldest winter of record
and mutiny among the ranks.

But not more than a mile up the Hudson River, different but equally
injurious punitive actions were being instituted—an act of attainder. In
1711, the Bayard family came into possession of five-hundred-plus acres of
waterfront land at Hobocan, just below the palisades and directly across from
the city of New York. This prime land was originally granted on February
5, 1663, by Dutch governor Peter Stuyvesant to Nicholas Varlett. The

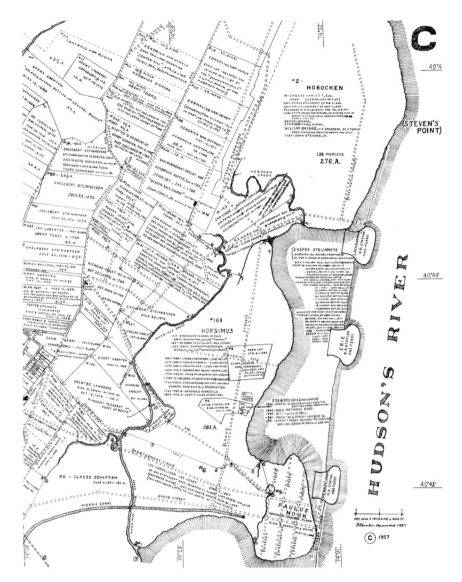

Hoboken and Paulus Hook as depicted on a map of Bergen (1660–68) compiled by D. Stanton Hammond. *Genealogical Society of New Jersey.*

Articles of Capitulation would maintain the title, and five years later, New Jersey governor Philip Carteret would confirm the Dutch title by deed.[117] The heirs of Varlett would convey these lands to Samuel Bayard, and they would descend through generations, eventually becoming vested in William Bayard.

Bayard, a prominent and influential New York merchant and the great-great-grandson of Anne Stuyvesant, sister to the venerable Peter Stuyvesant, was in possession of this legacy at the advent of the American Revolution. Bayard served as a delegate to the first Stamp Act Congress in 1765.[118] Later, he would be associated with the Sons of Liberty, and he frequently engaged and entertained various delegates to the Continental Congress as they passed through New York and New Jersey on their way to Philadelphia. His cause was liberty and the rights of Englishmen. When rebellion turned to Revolution and General Washington fled across New Jersey in retreat from New York in late 1776, Bayard chose to remain faithful to Mother England and joined the British forces as a colonel in the Loyalist militia. He now found himself the object of rebel anger. In 1778, it was reported in the *New York Gazette* that "Light Horse" Harry Lee had taken all of Bayard's livestock and, later in 1780, "burnt Col. William Bayard's new home and barn, on the north end of Hobuck, and destroyed all the forage and timber."

It did not end there, for in the January term of 1780, a writ or process of forfeited estates was issued out of the court of common pleas of the county of Bergen in New Barbadoes, and "final judgment was had in favor of the said State of New Jersey pursuant to law, against William Bayard late of the Township of Bergen on an Inquisition found against the said William Bayard for joining the Army of the King of Great Britain," pursuant to certain legislative acts.[119] These several legislative acts beginning in 1777 were simple, ambiguous and vague enough to be easily applied in general. The text of which is represented by this 1778 version:

> *An ACT for forfeiting to, and vesting in the state of New Jersey, the real estates of certain fugitives and offenders, and for directing the mode of determining and satisfying the lawful debts and demands, which may be due from, or made against, such fugitives and offenders; and for other purposes therein mentioned.*
> *Passed the 11th of December, 1778*

Bayard's lands were seized and forfeited under an act of attainder. Under English common law, attainder was a declaration of a person's "civil death" (extinction of all civil rights and capacities) and a legislative act that singled out an individual or group for punishment *without* a trial. The process in New Jersey was overseen by county commissioners appointed by the state. The commissioner in this matter was Cornelius Haring, Esq. Haring was responsible for investigating, compiling evidence and presenting it to a jury

of twenty-four freeholders (landowners), of which a simple majority would result in a conviction.[120] (Today, criminal convictions require a unanimous decision.) The inquisition was advertised and then sent to the court of common pleas, where the decision could be challenged. Certainly, Colonel Bayard could not appear before a New Jersey court even if he wanted to. (Undoubtedly, he would suffer the same fate as his house and barn, or worse.) The court would issue a writ, and then the property would be sold at public auction.[121] Although technically not an attainder in the strictest English sense, it was a de facto attainder.

The land was sold at public auction on March 16, 1784, to John Stevens Jr. (aka Colonel John Stevens III), who also happened to be the New Jersey state treasurer at that time. He paid the sum of £18,360 pounds for 564 acres (or approximately $159 per acre) of prime waterfront real estate. After Stevens passed away in 1838, his family subdivided and developed the property under the auspices of the Hoboken Land & Improvement Company and made a fortune. As part of this development plan, his heirs would petition the legislature to pass an act allowing them to fill the bay that separated Paulus Hook from Hoboken, what is today the land where the Holland Tunnel entrance is located.

Article I, Section 9, paragraph 3 of the U.S. Constitution, passed on September 17, 1787, provides that "No Bill of Attainder or ex post facto Law will be passed." Both Hamilton and Madison spoke strongly against the Common Law practice of attainder:

> *Bills of attainder, ex post facto laws, and laws impairing the obligations of contracts, are contrary to the first principles of the social compact, and to every principle of sound legislation…The sober people of America are weary of the fluctuating policy which has directed the public councils. They have seen with regret and indignation that sudden changes and legislative interferences, in cases affecting personal rights, become jobs in the hands of enterprising and influential speculators, and snares to the more-industrious and less-informed part of the community.—James Madison, Federalist Number 44*

Certainly, John Stevens was one of those "enterprising and influential speculators." The First New Jersey state constitution, enacted on July 2, 1776, did not contain any prohibition against attainder. William Bayard was not the only Loyalist to be attainted; there were many others here in New Jersey and in other colonies, like Mr. Parker Wickham from New York, who

John Steven's estate at Hoboken. *Courtesy of the New Jersey State Library.*

lost his land and estate on Long Island through a bill of attainder passed by the New York legislature on October 22, 1779.

William Bayard left America and would end his days in Southampton, England, in 1804. His story stands as an example of the tyranny dealt out under English common law and was one of the significant reasons for colonial America's thirst for liberty, freedom and independence. Individual property rights stood at the epicenter of the Revolutionary movement. The State of New Jersey's use of the attainder as a weapon against loyal British subjects, and Treasurer John Stevens's use of his influence and advantage to enrich himself shortly before the passage of a U.S. Constitution, which specifically and definitively expunged the practice from our new government and society, resounds with irony, if not worse.

Always remember that the soft veil of time often blurs the images of our forefathers. They were hard men in hard times. Both Loyalists and rebels would see themselves as Patriots. There was no precedent in the fledgling American law for enforcing attainder. William Bayard chose to defend the country and system of government that placed him in America and from whom his land title rights descended. He was the successor to the Native claims, Dutch claims and English proprietory claims. He did not acquire these lands through the fruits of ill-gotten gains; his family was invested with these rights long before there was talk of independence and a new nation.

Although he survived the war and returned to England, William Bayard should be counted as a casualty. The very same rights of property, over which the American Revolution was waged, were denied to William Bayard, and to the victor go the spoils. Fortunately, just a few years later, much more enlightened men like Hamilton and Madison clearly saw the tyranny of the attainder and would smite it with their pens.

Postscript

Similar to Benjamin and William Franklin, Bayard would also find himself on the opposite side of a broken relationship with his son. William Bayard Jr. was only fifteen years old when the war broke out, yet he fully embraced the Revolutionary spirit and remained in America when his father returned to England. He became a close friend of Alexander Hamilton, just six years his elder. As a New York City banker, he would see Hamilton as his mentor, and his affection ran deep. It was to Bayard's home in Greenwich Village that Hamilton was brought after his fateful duel with Burr. It was said that when Bayard saw Hamilton expiring in the boat that had just come from the Weehawken shore, a stone's throw from the Bayard family's attainted estate, he "was so overwhelmed by grief, he was almost useless." William Bayard Jr. would be one of the bearers who carried Hamilton's coffin to its final resting place at Trinity Church.[122]

In a strange twist of fate, on August 22, 1854, twenty-three-year-old Martha Bayard Dod would marry John Stevens's son, fifty-nine-year-old Edwin Augustus Stevens. Martha was a descendant of Anne Stuyvesant and of her grandson Samuel Bayard, who left New York in 1698 and moved to Maryland. The American Revolution and other circumstances brought her family back to New Jersey and back to the family who succeeded to the Bayard estate. After bearing seven children in fourteen years, as well as the death of her husband in 1868, Martha would be integrally involved in the management of the Hoboken Land & Improvement Company. She would go on to found the Stevens Institute of Technology along with her brother Samuel Bayard Dod.[123] It is certainly ironic that two distant relatives of the Loyalist who lost his property to forfeiture would return almost ninety years later to establish an institute of higher learning atop the land that was attainted so many years ago.

Chapter 9

SCANDALOUS SPEECHES AND INSINUATIONS: THE ASSAULT AGAINST THE BODY OF ALEHA PREST

Plus ça change, plus c'est la même chose.
—*Jean-Baptiste Alphonse Karr*

The fact that this next story occurred decades before the French critic would arrive at the universal truth that "the more it changes, the more it's the same thing" validates his conjecture. The events take place at the end of the summer of 1779, while George Washington and the Continental army were beginning to move inexorably toward their fateful encampment at Jockey Hollow outside of Morristown for what would be one of the most brutal winters of the Revolution. In his Circular to the States, Washington expressed his concern and frustration for his army and the men who served him: "We have never experienced a like extremity at any period of the War…Unless some extraordinary exertions be made by the States from which we draw our supplies there is every appearance that the Army will infallibly disband in a fortnight."[124] The background of war in Monmouth County at this time was no less extreme. In addition to the ongoing civil war between the county's Patriots and Loyalists and impromptu visits from "Light Horse" Harry Lee, Monmouth suffered a string of raids in April, May and June just down the road from Freehold, where the following offense was perpetrated.[125]

The land records are often used to make public information that has little to do with land transfer. Some have used it as a stage to present their grievances, memorialize their beliefs or display their arrogance. In

Monmouth County Deed Book H, there is a story of innocence, arrogance and retribution that could just as well have happened yesterday. It is a story that reveals that the human race has not advanced so far from our forefathers in civility or decency and that dispels some of the romanticism and nostalgic whitewashing that has gone on in the past two-hundred-plus years. It is the story of Aleha Prest, a sixteen-year-old girl from Freehold, who was publicly slandered by one Phillip Milligan, a man who claimed "that he knew her as well as he did his own wife."[126]

This was a serious insinuation that was not taken lightly in the eighteenth century. Aleha was entering a time in her life when she would be entertaining suitors, and she had only a few years before she might be labeled a spinster. Any suggestions that she was not a maiden could significantly reduce her chances for a suitable match. Aleha's father, Richard Prest, brought suit against Milligan, who was arrested and indicted on August 2, 1779, in the court of Oyer and Terminer for the misdemeanor of "Assault with an Intent to Ravish."[127] The indictment did not mention the victim, only the defendant, Philip Milligan. He pleaded not guilty.

The court of indictment was presided over by Justice Symmes, John Longstreet, Peter Forman and Peter Schenck, Esqs. On August 19, Milligan, after spending seventeen days behind bars, would change his plea to guilty. The final judgment was handed down by Chief Justice David Brearly, Thomas Forman and Peter Schenck, Esqs. The court sentenced Philip Milligan to "stand in the publick pillory this afternoon for the space of One Hour and that he be committed until his fees are paid."[128]

American society has moved past punishment by public humiliation, although not past ignominy, cruelty or bullying. Time in the stocks or public pillory was not a pleasant occurrence. The nineteenth-century poet and humorist Thomas Hood relates his singular experience in the pillory on the public stage:

> *It was a fine day for the pillory; that is to say, it rained torrents. It was about noon, when I was placed, like a statue, upon my wooden pedestal; an hour probably chosen out of consideration to the innocent little urchins then let out of school, for they are a race notoriously fond of shying, pitching, jerking, pelting, flinging, slinging—in short, professors of throwing in all its branches. The storm commenced. Stones began to spit—mud to mizzle—cabbage-stalks thickened into a shower. Now and then came a dead kitten—sometimes a living cur; anon an egg would hit me on the eye, an offence I was obliged to wink at. There is a strange appetite in human kind for pelting a fellow-creature.*[129]

Indictment of Philip Milligan in the Court of Oyer and Terminer for "Assault with an Intent to Ravish Aleha Prest," 1779. *Courtesy of the New Jersey State Archives.*

Plea of Philip Milligan in the Court of Oyer and Terminer for "Assault with an Intent to Ravish Aleha Prest," 1779. *Courtesy of the New Jersey State Archives.*

Sentencing of Philip Milligan in the Court of Oyer and Terminer for "Assault with an Intent to Ravish Aleha Prest," 1779. *Courtesy of the New Jersey State Archives.*

An example of punishment in the public pillory in the late eighteenth century. *Lithograph by James Charles Armytage.*

Besides the physical duress that might be endured while in the stocks, the far greater injury is to the reputation of the condemned. How do you look your neighbor in the eye when he was pelting you with rocks the day before? How do you enter the local tavern and demand the respect of your peers? His flesh wounds would heal, but Milligan's pride and reputation were forever damaged. What is known about Philip Milligan? He was married and lived in Freehold. He claimed that his statements were "only said to excuse himself…being used to Scuffle with the Young Folk." This presents a pathetic picture of a grown man spending his time trying to impress teenagers with his ribald humor and scandalous accusations.

Philip Milligan appears in the county tax ratables for Monmouth County for the years 1779 and 1780. His taxable estate in 1779 was valued at eleven pounds, two shillings and two pence. He possessed two horses, one cow and two pigs but did not own any taxable real estate. In this same year, Richard Prest's taxable estate was valued at sixty-five pounds. He also owned

five horses, fifteen cows, three pigs and three hundred acres of land. The following year, Milligan's taxable estate diminished to a value of nine pounds, four shillings and nine pence, while Prest's estate appreciated to a value of sixty-six pounds and ten shillings. No doubt the decrease for Milligan is a direct consequence of his legal troubles. In 1781, Philip Milligan no longer appears on the tax rolls, while Prest continues to prosper.

Prest was a landowner, and Milligan was not. That was a very important distinction in eighteenth-century New Jersey. The first record of Richard Prest owning land in Freehold appears in 1774.[130] Over the next twenty-five years, Prest would accumulate over three hundred acres of land in Freehold near the Scotch Meeting House on the road from Englishtown to Middletown Point.[131] Not only was the value of his estate almost eight times larger than Milligan's, but as a landowner, he also was a significant tax payer, and under the New Jersey Constitution of 1776, he was entitled to certain rights that Milligan did not enjoy.

> *ARTICLE III. That on the second Tuesday in October yearly, and every year forever (with the privilege of adjourning from day to day as occasion may require) the counties shall severally choose one person, to be a member of the Legislative Council of this Colony, who shall be, and have been, for one whole year next before the election, an inhabitant and freeholder in the county in which he is chosen, and worth at least one thousand pounds proclamation money, of real and personal estate, within the same county; that, at the same time, each county shall also choose three members of Assembly; provided that no person shall be entitled to a seat in the said Assembly unless he be, and have been, for one whole year next before the election, an inhabitant of the county he is to represent, and worth five hundred pounds proclamation money, in real and personal estate, in the same count.*

> *ARTICLE IV. That all inhabitants of this Colony, of full age, who are worth fifty pounds proclamation money, clear estate in the same, and have resided within the county in which they claim a vote for twelve months immediately preceding the election, shall be entitled to vote for Representatives in Council and Assembly; and also for all other public officers, that shall be elected by the people of the county at large.*

Milligan was not a freeholder, and he was not worth fifty pounds. He could not vote or hold public office. How sympathetic or lenient do you think the elected officials might be to Milligan? He was inconsequential.

Prest, on the other hand, was a large landowner and would possess a certain level of influence within the community. It is possible that this influence prompted the further action taken by the court two months later on October 18, 1779. The court presided over by Justice John Longstreet demanded that Milligan publicly apologize and renounce his statements, while also paying the considerable fine of £100 pounds to Richard Prest in addition to all the "charges of the said arrestment." The apology had to be in writing, signed by Philip Milligan and recorded in the clerk's office to remain for all eternity. The extant minutes of the court of Oyer and Terminer do not contain the details set forth in Deed Book H, page 336. They are but an abstract of the proceedings, providing little information and failing to name the victim. It is amazing that those documents have survived these 235 years. The apology shown below is not a deed or even a land document, yet it speaks volumes about the society and people in New Jersey during the midst of the great American struggle for independence. To that end, it is important to transcribe it entirely herein.

Whereas Phillip Milligan of Freehold who was indited at the Last Court for assault against the body of Aleha Prest Daughter of Richard Prest of the same place being allowed to say what induced him to the said assault said many false and ironious things in excuse against the said Aleha Prest and her character being the age of sixteen years and that he the said Phillip Milligan should have said since the Court that he knew her as well as he did his own wife and many more scandalous Speeches & Insinuations against her to her grate Damage for which he now stands arrested and whereas the said Phillip Milligan is willing to declare before any Justice of the Peace of our States that his Appoligy and Aligetions so said by him against her is false and Ironious and only said to excuse himself and that he knows no harm of the said Girl but being used to Scuffle with the Young Folk but ment no harm nor ment no harm in the said Freedom this he excepts under Oath and do by these presents Acknowledge to pay all the Charges of the said arrestment now Adwenced and that the Richard Prest should with draw his action now against him for the same and the said Phillip Milligan do bind himself in the junnol sum of one hundred pounds to be paid unto the said Richard Prest or his assigns for his Good Behaviour towards the said Richard Prest or his family or else to stand and remain in full force and Virtue or otherwise to be Void & of none Effect As Witness my hand this 18ᵗʰ day of October 1779.

Witness my hand
Phillip Milligan
Sworn before me the date above as it is set forth in the above instrument of
Righting
John Longstreet Justice
Recorded 20th October 1779 by Order of Court

Within a year, Philip Milligan had vanished from Monmouth County. The Prests continued to prosper. They sold their landholdings in Monmouth County around the turn of the century and moved to South Amboy Township in Middlesex County, in and around an area that is today part of Old Bridge and known as Deep Run. They purchased several hundred acres of new land that included a sawmill and an apple orchard. Richard and his wife, Sarah, would have eight children—William, Margaret, Jane, Aleha/Leah, Daniel, John, Eleanor and Peggy—and live on well into their eighties. William would inherit the majority of the land and mill property. Jane and Leah would remain living in their parents' home, and for some unknown reason, John would receive only one dollar under his parents' last wills and testament.[132] At the time of Richard's death in August 1823, only two of his daughters would be married: Eleanor and Peggy. Aleha Prest would spend her life as a spinster.

There is no way of knowing how this event in 1779 affected Aleha Prest. There is no testimony from her on the record. Was the "Assault and Attempt to Ravish" limited to just words, or were there more nefarious acts that might have scarred a young girl for the rest of her life? Milligan's time in the pillory and public apology certainly brought shame upon him and ultimately resulted in his leaving the county. But what of Aleha's shame? All of the torrid details laid out in the public record for everyone to read, for titillated school boys to finger and peruse in the clerk's office. For once a document is recorded in the clerk's office, it must remain there on public display for the rest of all time. This one brief cultural snapshot reveals a plethora of insights into society in the late eighteenth century while a world war, the American Revolution, cast its shadow on daily life.

Chapter 10

OTHER GOOD AND VALUABLE CONSIDERATION: THE STAMPS OF WAR

Quite often, historical researchers relate the fact that a certain property was purchased for only one dollar, erroneously assuming that it was a gift and waxing poetically about the benevolence of the grantor. In most instances, this is not the case. The more common language that signifies a gift would be "for love and affection." The secret is hidden in the revenue stamps attached to these deeds. When reviewing older deeds, people might wonder why they don't reveal the actual consideration and instead say "$1.00 and other good and valuable consideration."

It was 1765, and England found itself in a tenuous economic situation. Seven years of war with France had doubled the national debt up to £130 million (about $23 billion in U.S. currency today). Two years after the 1763 Treaty of Paris, England was in a desperate situation. So England passed a tax on the American colonies that required all documents to be printed on specially embossed paper, produced only in England, and to have a revenue stamp affixed thereto. This included deeds, contracts, playing cards, newspapers and all other forms of legal documents. As a matter of fact, any document that did not have the stamp affixed on it would not be accepted as valid in a court of law.

The passage of the Stamp Act of 1765 was one of the seminal events in the American independence movement. The colonists vehemently rose up, protesting in the streets, and convened the Stamp Act Congress. Within five months' time, the act was repealed. The Americans had cast off the specter of the revenue stamp, banishing it from the American landscape.

A five-dollar red conveyance revenue stamp, circa 1862. *Courtesy of the Monmouth County Archives.*

Or so they thought. Besides escaping centuries of religious intolerance, systemic poverty and oppression, our ancestors came to America for relief from the unending cacophony of war. Yet when looking back on American history, war assumes a very prominent role and has cost much in life and treasure. So how were all those wars paid for? The answer is STAMPS.

In 1862, in the throes of a terrible Civil War, Salmon P. Chase, secretary of the treasury, reached back in time and grabbed hold of the revenue stamp as a way to fund the Union war effort. Congress passed the Revenue Act of 1862, which increased taxes by establishing the first federal income tax and requiring the use of adhesive revenue tax stamps on all sorts of items, including deeds of conveyance. (It also created the Bureau of Internal Revenue, aka the Internal Revenue Service).

An example of the first issue of stamps for conveyances in 1862 is shown here with the picture of George Washington. Modern title professionals would not be familiar with these stamps, as they were used before the advent of the photocopier; instead, handwritten notations are all that can be seen in the land records.

The 1862 documentary stamp tax was repealed in 1872, but the cost of the Spanish-American War brought stamps back when reintroduced by Secretary

Above, left: A three-cent green proprietary stamp, circa 1862. *Courtesy of the Monmouth County Archives.*

Above, right: A two-cent orange U.S. Internal Revenue stamp, circa 1862. *Courtesy of the Monmouth County Archives.*

Top, left: A two-cent orange express revenue stamp, circa 1862. *Courtesy of the Monmouth County Archives.*

Top, right: A two-cent blue bank check revenue stamp, circa 1862. *Courtesy of the Monmouth County Archives.*

Top: A ten-cent brown USS *Maine* documentary stamp, 1898. *Courtesy of the Monmouth County Archives.*

Left: A two-cent red USS *Maine* documentary stamp, 1898. *Courtesy of the Monmouth County Archives.*

of the Treasury Lyman J. Gage under the Tax Act of 1898. (Lyman's face would show up on revenue stamps in the future.) The United States has a long history in the use of revenue stamps on everything from promissory notes, deeds, stock transfers and bills of sale to tobacco, playing cards, perfumes, matches, narcotics and even potatoes.

The stamps seen above are Series O documentary revenue stamps bearing a picture of the USS *Maine*. They are affixed to an accompanying title search that was performed by the Camden County register on October 28, 1898. Not

A Camden County title search with documentary revenue stamp, 1898. *Courtesy of Patrick Brennan.*

only did the deeds of conveyance bear the revenue stamp—so, too, did the title searches issued by the registers and clerks. (Today, title searches are exclusively performed by independent title research professionals.) This search is in the personal collection of the venerable and celebrated title man Patrick Brennan and is the oldest extant title search that this author is aware of. (If you know of others, please let me know.) The fee charged by the register to perform the search was $9.97. It seems like a bargain when compared to current title search costs ($75.00–$100.00). But when adjusted for inflation, $9.97 is today worth approximately $226.00.

It was a short conflict with Spain, and by the end of 1902, documentary revenue stamps were once again repealed. But sure enough, in 1914, they came roaring back. Unlike the Civil War and the Spanish-American War, it appears this time that the U.S. Treasury saw the writing on the wall and started collecting stamp tax revenue again, before the country's entry into the next war.

First copies of revenue stamps by photocopier, circa 1953. The stamps were presented in a negative image until technology changed. *Photograph by Heather Paich.*

With the advent of photocopiers in 1952, the stamps pictured above would have been the first ones that title searchers actually saw, in black and white and negatively exposed. Prior to that, the tax stamp information would be handwritten on the deed. The actual stamps are affixed to the original deeds, which are then returned to the buyer. The individuals pictured on many of the stamps are former secretaries of the treasury from the nineteenth century. Salmon P. Chase, who started it all in 1862, would never appear on the revenue stamps that he fathered. However, he would go on to become the chief justice of the U.S. Supreme Court and appear on the $10,000 dollar bill.

The tax since 1862 was $1.00 for every $1,000.00 of consideration paid in a deed. So a $12,000.00 conveyance would be affixed with $12.00 in U.S. revenue stamps. In July 1940, the tax was raised to $1.10 per $1,000.00 and remained at this rate until 1968, when the federal government withdrew from documentary taxation. The State of New Jersey immediately stepped

Handwritten stamp abstract from a recorded deed, 1898. *Photograph by Heather Paich.*

in and instituted what we know today as the New Jersey State Realty Transfer Fee (NJSA 46:15-7.1). It began at $1.00 per $1,000.00 and now stands at $5.80 per $1,000.00 for the first $150,000.00 of consideration and increases exponentially from there up to $12.10 per $1,000.00 for transactions in excess of $1 million. Initially, this fee was payable by the grantor upon transfer of title in New Jersey. The law has gone through numerous modifications over the years. In 2004, a major change occurred when the tax was extended to buyers of residential real estate valued in excess of $1 million; it was affectionately referred to as the "mansion tax." This was a significant shift from the past and required the executing of a new affidavit form, RTF-1EE, to be annexed to any deed in excess of $1 million. In 2005, the tax was extended to include Class 2-Residential, Class 3A-Farm and Class 4C-Residential Cooperative Unit. Just one year later, in 2006, it was extended to also include Class 4A-Commercial Property. Today, in many cases, a transfer tax will be applied whether one is buying or selling real estate in New Jersey. Just across the border in New York, taxes are imposed on both deeds and mortgages, and additional taxes are imposed in New York City.

When viewing an older deed from 1959 that is affixed with $117.70 in stamps and states that the consideration is "one dollar and other good and valuable consideration," you will know that the actual sum paid for

WM. KRUEGER
Wm. Krueger

$.50 I.R.U.S. Stamp Cancelled

Left: Typed stamp abstract from a recorded deed, 1935. *Photograph by Heather Paich.*

STATE OF NEW JERSEY,)
 SS:
COUNTY OF MONMOUTH)

Below: New Jersey State Realty Transfer Fee stamp, 1972. *Photograph by Heather Paich.*

March , in the year of our Lord

single person,

Drive,

COUNTY OF MONMOUTH
CONSIDERATION 17,900
REALTY TRANSFER FEE 18.00
DATE 3-16-70 BY C.R.

Keyport in the County
New Jersey,
ed as GRANTOR,

the property was $107,000.00 and that the transfer helped pay for the Korean War and/or possibly the Vietnam War. Real estate has always been recognized as the cornerstone of the U.S. economy, but who knew that the defense of the nation was funded in part on the good and valuable consideration paid for land transfers?

Chapter 11

NO JUSTICE FOR MR. GLENN

New Jersey has always been a place where opportunities abound. Accomplishments both large and small have contributed to the brilliant fabric of the state's history. Whether talking about Thomas Edison, the Wizard of Menlo Park, or a college dropout who, armed with just a pencil and clipboard, would rise to prominence in the title insurance industry, this state has provided a lush garden in which to nourish the dreams and aspirations of millions. One of the key ingredients of this success is land and landownership. Whether it was the land necessary to build the laboratories in Menlo Park and West Orange or the research of the land records to ensure the proper, orderly and secure transfer of title to those lands, real property was one of the pivotal elements to success.

John W. Glenn of Trenton had similar aspirations in 1850 as he toiled in a local foundry at the age of nineteen. Many of his friends in the Third Ward worked with him molding iron or at other jobs involving intense physical labor, such as stonemason, blacksmith, machinist or potter. Trenton was a booming industrial center, and no one was aware that a great Civil War was only a decade away. John was the eldest of five siblings and the only son of James and Artemisia Glenn. Born in Pennsylvania, John came to Nottingham Township (later to become part of Trenton in 1856) as a boy of ten years. His father, James, was the master of a ship that plied the waters of the Delaware, moving finished products downriver to Philadelphia and around the cape to New York. This kept him away from home for extended periods, and John had to grow up fast, assuming his familial responsibilities

as the eldest son. Life in a cramped row house in a nineteenth-century industrial town was not an enviable situation. The mortality rate was high. In 1860, more than half the deaths in the Third Ward were children under the age of nineteen, and the vast majority were caused by communicable diseases such as consumption, dysentery, bilious diarrhea, dropsy and lung ailments.[133] It was in that year that John's mother, Artemisia, died of lung fever at the age of fifty-six.

John was still working at the foundry as a moulder in 1860. He had gotten married to Helena H. Jones in 1854 and was now the head of the household with two children of his own, Laura and James. He also bore the added responsibility of taking in his father, now the captain of a schooner, and his two minor sisters, Emily and Katy. It was a hard life on what little he could earn in the heat of the foundry furnace—certainly his father, James, would contribute; they each had some personal valuables. Even eighteen-year-old Emily brought home a few dollars as a dressmaker, but the family was still renting a row house in the Third Ward. All seven of them were living there, with another child on the way.

John W. Glenn was a hard worker, but he had greater dreams. He looked around the neighborhood and saw that the most successful men had two things: a business of their own and the deed to the house in which they lived and the land on which it stood. Even his next-door neighbor, Lewis Scofield, the supervisor over at the rolling mill, didn't own his home. He, like most on the block, was a renter. Yet Lewis Parker, the innkeeper, was a homeowner, just like butcher Septimus Weatherly and twenty-four-year-old William D. Sinclair, who owned his own tailor shop.

The year was now 1867, and the Glenn family continued to expand. At thirty-six years old, John W. Glenn resolved to make a change in his life and pursue his dream of becoming a grocer. Today, the landscape is dominated by Super Walmarts and warehouse stores, but in 1867, the local grocer served his neighborhood, bringing fresh fruits, vegetables, coffee, spices, meats and dry goods within walking distance of the row houses. As the proprietor of a grocery, John would be respected in the community. He needed two things: a good location to operate his business and credit to obtain the inventory he would need to open his shop. Land would be the solution for both of these needs.

Glenn had his eye on a prime location at the corner of Market and Warren Streets, just a block from the waterfront and the foundry where he had worked for seventeen years. John was counting on the patronage of his former coworkers walking home from the Phoenix Iron Works, Walton's Roller Mills and the Wilson Woolen Mill, as well as the local residents. It was a three-story

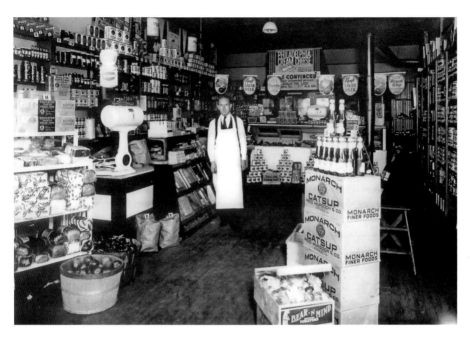

Above: A typical late nineteenth-century urban grocery. *Courtesy of Randall Gabrielan.*

Left: A Sanborn Insurance map of Trenton (Sheet 28, 1890) showing John Westly Glenn's grocery store at the corner of Market and Warren Streets. *Courtesy of Trenton Public Library.*

brick building with storage buildings in the back for dry goods and a wooden porch extension on Warren Street to display the fresh fruits and vegetables. It was for sale, and all Glenn needed was $1,200 to seal the deal. He signed the contract and leveraged the property as collateral for a series of loans.

John must have done pretty well for the first few years. He moved the family across the river to Morrisville and was listed as a merchant in the 1870 census. With real estate valued at $7,000 and personal assets valued at

$3,500 between him and his wife, it appeared that John had finally arrived. However, things are not always as they seem. The land records reveal a somewhat different story. Assets are only one side of the ledger. John and Helena were required to give six mortgages on the property at the corner of Warren and Market, and in August 1869, their creditors came to call. Although Congress had passed a federal bankruptcy law in 1867, most small businesses chose to handle their debts under a state process known as Assignment for the Benefit of Creditors. This process was handled through the county surrogate, wherein an inventory would be made of all the debtor's assets and liabilities, and then the debtor would assign all of those enumerated assets to a third party in order to work out their indebtedness, much as a trustee does in a Chapter 11 Bankruptcy today.

In this case, the inventory and assignment were found recorded on page 14 of Special Deed Book B in the Mercer County Clerk's Office. John and Helena assigned all their interest in the store, fixtures, stock, accounts and "cash on hand" to Philip H. Wentz on August 21, 1869.

Assets	
House & Lot at Warren & Market	8,000
Household Goods	150
Stock in Store & Fixtures	1,000
(Cor of Warren & Market)	
Book Account	600
Cash on Hand	120
TOTAL	$9,870.00

Creditors	
Wm Colton & Co	927
Mills Stout & Co	1,528
James Ronan	529
Leeds & Holmes	730
John Stout	465
Jacob E Carter	253
Chipman & White	57
TOTAL	$4,489.00

The list included Mills Stout & Co. of New York City, Chipman & White of Philadelphia and Jacob E. Carter from Yardleyville, Pennsylvania, with Mills & Stout being his largest creditor. These larger out-of-state creditors would have no patience for small debts such as these. The Glenns had more than sufficient assets to cover their liabilities. They were not, however, all liquid, and within less than two years, the mortgage holders would bring suit to foreclose on the six mortgages.[134] It would appear that John Glenn's dream was shattered, but that is not the end of the story. Helena and John were able to work out a program wherein they continued to operate the grocery down the street at 253 South Warren Avenue. Their young son James worked as a clerk in the store, and the family was back on their feet again. They accomplished this through the benevolence and trust of their neighbors. Helena turned to other Trentonians, Howell & Son, for flour and local wholesale grocers West, Cole, Case & Co.; D.P. Forst & Co.; Thomas B. Taylor; and Lanning Brother & Co. for additional stock. For spices and coffee, they visited Garret D. Parks and, seemingly, their best friend, James Ronan. Their final visit would be to John Taylor to acquire some of that peculiar ham that everyone in Trenton seemed to enjoy. This was an example of the community coming to the aid of a fellow businessman. This time, it was Helena H. Glenn who would pledge repayment to the creditors.

Unfortunately, almost three years from the date of the first assignment, Helena would find it necessary to assign her assets to Charles W. Street to appease their creditors.[135] There was no real estate left, and this time the liabilities far out-stripped the assets. For several years afterward, John W. Glenn would continue to be listed as a grocer in the Trenton City Directory— maybe he worked for another grocer or struggled along renting a small shop and relying on the charity of his friends—friends such as James Ronan, the only one of the Glenns' creditors who came back the second time and took a chance on them. Not much older than John Glenn, Ronan had experience that Glenn did not. He had a background in the grocery business, having worked for merchant Anthony R. Ranier as a clerk for over twenty years before branching off with his own spice and coffee business. He became quite successful, living with his wife, five children and two servants in a grand house on Clinton Street. He showed great faith in Glenn, but it was all for naught.

By 1879, the Glenns were back to renting a row house in the old neighborhood at 319 Fair Street. They now had six children, with one more on the way. John was making money as a paperhanger, his aspirations having been dashed. A new daughter, Helena, would arrive in April 1880. John went back to the foundry working as an iron moulder. His son Herbert, now

A list of John W. Glenn's 1872 assets and creditors, as contained in the Mercer County Special Deed Book. *Photograph by Heather Paich.*

nineteen, found work as a day laborer, while the elder son, James, was living in the same house on Fair Street with his new wife, Susan, and employed as a machinist. In just thirteen short years, John Westly Glenn's life soared and then crumbled into ruins. John died at the age of forty-nine on July 7, 1880, leaving behind a wife and seven children, the youngest of whom was only three months old. He lies at rest in the Riverview Cemetery in Trenton.

Not all dreams come true, no matter hard work or perseverance. John and Helena attempted to use the power of real property to finance their business venture. The value of land and the collateralization of debt through mortgages was a well-established economic principle. Land in general tends to increase or at least hold its value over time. The problem here might have been a bad initial business decision followed by inexperience in running a business on the eve of a financial panic. (The Panic of 1873 was known as the Great Depression up until 1929.) In 1867, at the time the Glenns decided to open their grocery store, there were already ninety-five advertised grocers in the Trenton City Directory. It was a rather saturated market. While full of good intentions, the Glenns had absolutely no experience in running a grocery or any type of business, for that matter. Even today, supermarkets run on a very tight margin. Failure to adjust labor costs, inventory and expenses can quickly find a business in the red.

The land records maintain the history of families like the Glenns of Trenton. These land documents mark the events in their own personal history and tell the story of a courageous family who took their shot at the American Dream while risking everything. When visiting the Trent House, look across at the small park in front of the Richard J. Hughes Justice Complex—there is the site of John Glenn's broken dream.

Chapter 12

THE SILK KING'S TREASURE: CATHOLINA LAMBERT

He was undersized, to start with, and never, if he could help it, let anybody take his picture standing up. But he was feisty too.
—*Flavia Alaya,* Silk and Sandstone

Sitting high above the city of Paterson is an imposing edifice, its grand stature juxtaposed against a sprawling city where many dreams were made and crushed. As he strolled out onto the veranda of that structure, looking down on the city and the silk factory that bore his name, Catholina Lambert had a heavy heart and an awful decision to make. It was August 1, 1914, and Germany had declared war in Europe. Lambert had survived the great Silk Strike of 1913, his head "bloodied but unbowed."[136] What did "they" know about hardship and strife? Were they sent away from home at ten years of age to work in the Boar's Head Mill in Derbyshire? Did they risk everything at seventeen, leaving England behind, with a twelve-year-old brother in tow, to come to America with no money, no prospects and only an indomitable nature on which to rely? Sure, he had prospered in Boston under the tutelage of Anson Dexter, rising to a partnership position in just four short years. But he earned that through tireless effort and a keen eye for business. He was a man at seventeen and had no time for dalliance. Three years later, he was in charge.

At the age of twenty-three, Catholina Lambert had earned his success and also earned the affections of Isabelle Shattuck; they were married on September 9, 1857. Silk was booming, and Paterson's Great Falls would provide all the energy

An 1888 letterhead for Dexter, Lambert & Co. showing the four locations of the company and a lithograph of the front gate of the factory on Straight Street in Paterson, New Jersey. *Courtesy of the Passaic County Historical Society.*

Postcard of Lambert's Belle Vista castle in Paterson, New Jersey. *Courtesy of Randall Gabrielan.*

that Lambert needed to soar to great heights and land upon Garret Mountain. Although he maintained his residence in New York City and then Brooklyn from 1859 to 1888, as early as May 1, 1862, Catholina Lambert began to purchase land in and around Paterson.[137] The first parcel was a $12,000 piece of property with a $9,000 mortgage.[138] Catholina had made his mark with Anson Dexter as a "$4-a-week bookkeeper" and quickly grasped the concepts of credit and collateral.[139] Early on, Catholina used the magic of mortgage lending to grow his business. Once successful, he would not have to visit it again until 1914, but that would be a very different type of mortgage.

And so there he stood in August of that year, alone on the porch of Belle Vista, trying to decide his fate. He was not a stranger to hard decisions. You don't become one of the most powerful silk barons with operations in Paterson, New Jersey, and Hawley and Honesdale, Pennsylvania, without having to break a few eggs—all while watching your family slowly but methodically pass on to another world. Catholina and Isabelle would have eight children, only one of whom, son Walter, would still be alive in 1914. They fell to the ravages of diseases that were well known, but even Lambert's success, wealth and power could not prevent the onset of cholera, scarlet fever and pneumonia.

Maybe that was why he built his castle on the hill, Belle Vista, in 1892. By then, six of his eight children had died, and he needed to create something permanent—something that would lessen the pain of loss, something that would console his inconsolable bride. With the help of his brother-in-law, John C. Ryle, in one year, he constructed a formidable battlement on the side of the mountain—a manifestation of the defenses that had grown around his vulnerable heart. A heart that needed to be filled again with joy and grace and art! On an early trip to Paris, Lambert had purchased a landscape by the French painter Georges Michel. It captured a soft spot in what was generally seen as an "iron will."[140] Over the next forty years, Lambert would amass one of the largest private art collections in the United States. Belle Vista became a veritable Louvre on the Passaic. In 1914, the collection included 428 paintings and 34 pieces of statuary. The artistic efforts of names such as Courbet, Delacroix, Lawrence, Monet, Monticello, Pissaro, Rembrandt, Renoir, Sisley and Van Dyke consumed every square inch of wall space within his castle, which would require the further addition of a one-hundred-foot-long art gallery to house his treasures. This was not just a rich man with disposable income who wanted to have the biggest art gallery on the block. In the later part of the nineteenth century, many of these artists, like the schizophrenic American painter Blakelock, had yet to

Frontispiece from the commemorative art book that Catholina Lambert gave to special guests when visiting Belle Vista. *Photograph by Billy Neumann; courtesy of the Passaic County Historical Society.*

achieve acceptance and fame within the art world. Even the venerated Claude Monet was a neophyte in 1873 when he had his first exhibition. In 2008, one of Monet's paintings would sell for over $80 million. Catholina Lambert was a patron of the arts with a keen eye for greatness. His collection would become known as "The Famous Catholina Lambert Collection." He went so far as to have a selection of masterpieces printed on silk and bound for presentation to special guests of the castle.

Pacing along the ramparts, Catholina had a decision to make. He could not truly confide in his second wife, Harriet, the way he did in her sister, his beloved Isabelle, who had passed away in 1901, less than ten years after

he had built this mountain sanctuary for her. His creditors were asking him to execute a mortgage to the Paterson Safe Deposit & Trust Company as trustee, a mortgage the likes of which had never before been recorded in the state of New Jersey! It was thirty-five pages long and included all his real estate in New Jersey, Pennsylvania and Massachusetts, as well as his entire art collection, which would be enumerated in the mortgage by room and location of each piece. The trustee had the right "to make sale of any part of said real estate by private sale at any time they may deem it advisable." The mortgage went on further to state that the works of art could also be sold, but only "with the assent of Mr. Lambert." He retained some minimal control over the art collection but suffered the indignity of having to survive on "a sum not exceeding One thousand Dollars ($1,000) per month for his personal and living expenses" during the two-year period of the mortgage, which Lambert had to pay back with interest. Additionally, all the property, real and personal, of Dexter, Lambert & Co, had to be transferred over "to three trustees, namely Edward Bell, Emanuel Garli and Edwin J. Ross, with power to…reorganize or wind up the business of the firm." There were twenty-seven creditors, and Catholina had to sign a separate promissory note to each and every one of them, being secured by this one mortgage document, on all of his worldly assets. At the end of the two-year period, if the twenty-seven promissory notes were not paid, the mortgage would be in default, and all the assets would be sold. The mortgage contained nineteen tracts of land, along with specific water and power rights.

Should he yield, give up the business, sell and walk away, or endure, sign the mortgage and hope to catch some of the Lambert magic that had sustained his business interests for over fifty years? How would he explain it to Harriet? She, too, would have to sign the mortgage—that was the law. The once great Catholina Lambert, the Silk King of Paterson, was reduced to surviving on $1,000 per month and no longer in control of his own destiny. He signed the mortgage on October 20, 1914, and it was held in trust until January 7, 1916, when it was recorded in the Passaic County Register's Office.[141]

Alas, Lambert would never recover, and in February 1916, the trustees auctioned off his famous art collection at New York's Plaza Hotel. In total, 368 paintings and 32 pieces of sculpture were sold that day for a reported $500,000, one-third of its expected value and well below what is known to be its current value.[142] Lambert attended the auction and kept copious notes on each item. In his copy of the auction book, Catholina wrote the expected value in the right-hand margin and the actual sales price in the left. It must have been another crushing, heartrending experience as he sat and watched

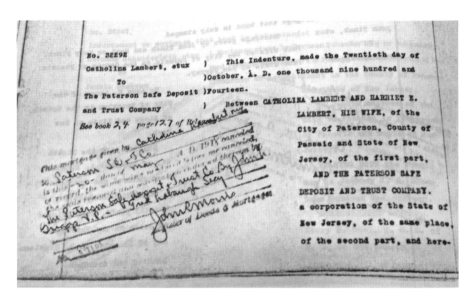

Catholina Lambert's 1914 assignment for creditors, as recorded in a mortgage book in the Passaic County land records. *Photograph by Heather Paich.*

Auction catalogues for the famous Catholina Lambert Art Collection, 1916 and 1925. *Photograph by Billy Neumann; courtesy of the Passaic County Historical Society.*

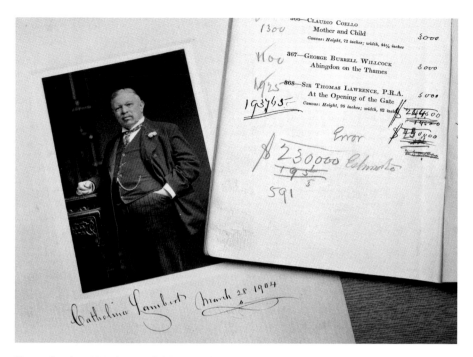

Photo of a circa 1904 image of silk baron Catholina Lambert and his personal copy of the 1916 art auction book. *Photograph by Billy Neumann; courtesy of the Passaic County Historical Society.*

400 more deaths. Before the end of that year, there would be one more, as Harriet would also pass away. Yet reports of the time noted that Lambert was cheerful and reserved as he sat there all four nights of the auction.

Catholina Lambert was a man of property. He understood the value of the land where he built his factories, his homes, his business and his art gallery. He also understood the value of equity and the ability to collateralize debt through the use of the mortgage. In the end, though, he could not have imagined such an ignominious finale to a life that tore from both ends of the envelope—the passion and the pain. Catholina would live on seven more years and then die almost on the anniversary of the auction. His son, Walter, would auction the remainder of his collection in June 1925. Walter sold the castle to the City of Paterson for $125,000.[143] Today, Belle Vista is a museum and home to the Passaic County Historical Society, once again filled with a variety of artwork indicative of Lambert's collection. It is certainly worth the trip to Paterson. It is also worth the trip to the county clerk's or register's office to find more hidden history.

Chapter 13

NEW JERSEY TO DELAWARE: CROSSING THE STATE LINE WITHOUT GETTING YOUR FEET WET

The genius of today's decision is that it creates irrationality where sweet reason once prevailed.
—Justice Antonin Scalia

Ever wonder why one parcel of land ends and another begins at a certain place? How those boundaries got established in the first place? Property boundaries are invisible lines that defy the thickness of a single sheet of paper. The boundary line is, in fact, a fiction. It is not a line at all. It is the point in space where one individual's rights end and another's begins. Of course today we rely on subdivision maps and deeds that were created with advanced surveying technology that bounces invisible beams off global positioning satellites located 12,600 miles above the earth and spins around the planet at 8,653 miles per hour.

In 1682, surveyors would also use the newest technology available, Gunter's chain, invented by English mathematician Edmund Gunter in 1620. Prior to that time, a variety of devices and systems were used for linear measurement, chief among them the rod. This was a sixteen-and-a-half-foot rod or pole that would be repeatedly laid on the ground to determine distances. In an account of Benedict Arnold's attack on the garrison of St. John on Lake Champlain in May 1775, militia captain Eleazer Oswald recounted that their force had landed "about sixty rods distance from the barracks."[144] Our current system of feet and inches was not used to measure land in the seventeenth and most of the eighteenth century. All distances

were based on the length of the rod. The rod was also alternatively referred to as a perch, although the perch could signify a linear measurement as well as a square measurement. The perch is predominant in the descriptions contained in deeds for property in the southerly portion of New Jersey, roughly coinciding with the former province of West Jersey. It could be confusing, as many land descriptions tend to be from the colonial period. All colonial roads were laid out as two-rod (thirty-three feet), four-rod (sixty-six feet) or six-rod (ninety-nine feet) roads, the latter being generally known as a turnpike road or King's Highway. State Highway Route 27, the Middlesex-Essex Turnpike, is one such example.

However, carrying a 16.5-foot pole around through the woods was not the easiest way to perambulate real estate. Gunter came up with the idea of creating a collapsible metal "chain" four rods in length, which would contain one hundred equal "links" with a handle on each end. It would require two men to operate. This was a flexible measuring instrument that could be kept in a small pouch, easily carried across the land, AND it was four times as long as the rod. The chain also allowed for a more exact measurement rather than four and one half rods or fifteen and two thirds of a rod. While this was a vast improvement, the dense forests, varying topography and lack of a developed road system still made it extremely difficult to survey land and therefore accurately describe it. So a chain is 66 feet long, with each link being 7.92 inches. An acre, 43,560 square feet, is simply ten square chains. A mile, 5,280 feet, is eighty chains. Converting chains and links to feet and inches is a very simple calculation. Decimalize the chains and links and multiple by sixty six, i.e. forty-two chains and seventy-two links = $42.72 \times 66 = 2,819.52$ feet.

But what about long distances or across bodies of water? How did they establish boundaries between states? Did they climb up a tree or go to the steeple of a church? Down in South Jersey, there is a place that lies in the shadow of the Delaware Memorial Bridge. Just outside the town of Pennsville, there is an old Civil War fort called Fort Mott. When walking directly north from that fort along the New Jersey shoreline, you will cross over the state line into Delaware.

Unlike most rivers, the boundary between New Jersey and Delaware does not run down the middle. Instead, the state of Delaware runs right up to the New Jersey shoreline. Go to Fort Mott State Park and jump into the water, and you are in Delaware! But you don't even have to get your feet wet, because 230-plus acres of the New Jersey peninsula is actually in Delaware! In order to keep the channel clear, the dredged soil has been pumped onto the Jersey side of the river for years, creating a growth on the

Jersey peninsula. Reference to any common map of New Jersey will reveal this unsightly blemish. The islands in the river also belong to Delaware.

How can that be? Well, on August 24, 1682, the Duke of York, the same individual who conveyed New Jersey to Berkeley and Carteret, conveyed the town of Newcastle to William Penn. (Delaware was originally part of the greater dominion of Pennsylvania and was referred to as the "Lower Counties" until it established a separate government in 1704 and ultimately seceded in 1776.) The description in Penn's grant contains the following language:

> *All that the Towne of Newcastle otherwise called Delaware and All that Tract of Land lying within the Compass or Circle of Twelve Miles about the same scituate lying and being upon the River Delaware in America And all Islands in the same River Delaware and the said River and Soyle thereof lying North of the Southernmost part of the said Circle of Twelve Miles about the said Towne.*

William Penn confirmed his title in Newcastle on October 28, 1682, when he took part in that peculiar custom of land transfer known as livery of seisin.[145] Penn took physical possession of the land "by the delivery of turf and twig and water and Soyle of the River of Delaware. We did deliver also unto him one turf with a twig upon it a porringer with River water and Soyle in part of all what was specified in the said Indentures or deeds."

Now, the Twelve-Mile Circle did overlap the peninsula of New Jersey, and the Duke, however powerful he might be, could not sell the same land twice. New Jersey based the title on the grant that Charles II had given to James on May 12, 1664, predating Penn's claim by 20 years. Unfortunately, the title did not include the bed of the Delaware River. The description in that grant, which would succeed to Berkeley and Carteret, stated that it included "all the land from the west side of Connecticut River to the east side of Delaware Bay."[146] This set the table for a title dispute that would stretch out over the next 250 years. It was in 1934 that the issue was finally decided before the U.S. Supreme Court in *State of New Jersey v. State of Delaware, 291 U.S. 361*. The court ruled that Delaware held primacy over the waters of the Delaware and land underneath within the Twelve-Mile Circle, measured from the center of the cupola of the courthouse in Newcastle. The Supreme Court stated in its decision:

> *New Jersey argues that they have, though not even during those years does she build her claim of title upon instruments of record. Her claim is rather*

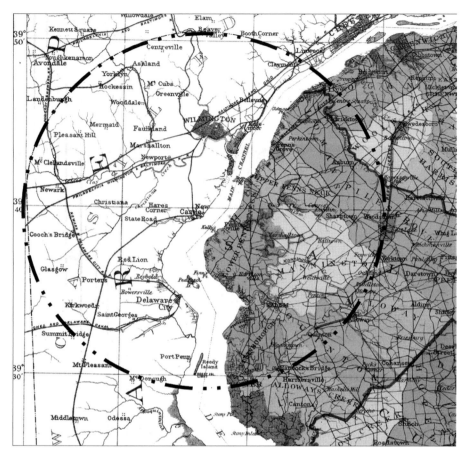

A 1906 map showing the boundaries of the Twelve-Mile Circle as described in the 1682 grant from James, Duke of York, to William Penn. *Author's rendering.*

this, that through the exercise of dominion by riparian proprietors and by the officers of government, title to the subaqueous soil up to the centre of the channel has been developed by prescription. The special master held otherwise, and we are in accord with his conclusion.

Normally, the boundary between two states is determined by the use of the Grotian Method, down the middle equidistant from the shoreline, or the Thalweg Principle, which asserts that the natural boundary line runs along the thalweg or deepest channel of the river. The court did rule in favor of New Jersey by applying the Thalweg Principle in determining the remaining boundary, outside

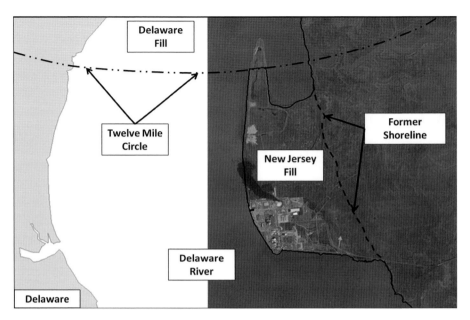

A current map showing the boundaries of the Twelve-Mile Circle as described in the 1682 grant from James, Duke of York, to William Penn, revealing the filled portions adjacent to the Jersey shoreline, which are actually in Delaware. *Author's rendering.*

the circle, between New Jersey and Delaware. This was a small consolation for the Garden State. The matter was revisited and reconfirmed in *State of New Jersey v. State of Delaware, 295 U.S. 694* (1935), wherein the court took the unique position of enjoining either state from ever disputing the "sovereignty, jurisdiction, and dominion" of the other state. The court viewed the matter as settled, and there was no reason to ever question it again.

Well, on October 17, 2007, the U.S. Supreme Court resurrected this issue once again as it agreed to hear New Jersey's challenge to Delaware's attempt to block the building of a liquefied natural gas import facility by British Petroleum on the New Jersey side of the river. The Special Masters Report was decidedly against New Jersey. Oral arguments were heard before the court on November 27 in the matter of *New Jersey v. Delaware, 552 U.S. 597* (2008). The vote of the Supreme Court was 6–2 in favor of upholding Delaware's rights up to the Jersey shoreline within the Twelve-Mile Circle. The two dissenting judges were both from New Jersey.

Chapter 14

WHY DOESN'T NEW JERSEY DUMP ITS GARBAGE ON STATEN ISLAND?

When I was a young boy growing up in Sayreville, I would often take my bicycle over the Old Victory Bridge across the Raritan River and into the historic city of Perth Amboy. These jaunts of wanderlust resulted in my discovery of Thomas Mundy Peterson, the first African American to vote under the Fifteenth Amendment (March 31, 1870), who lies peacefully in the graveyard at St. Peters Church and the Proprietary House, where William Franklin, last royal governor and son of Ben Franklin, was arrested during the Revolutionary War.[147]

Invariably, I would be drawn down to the waterfront, along the Arthur Kill (Dutch for "riverbed" or "creek") to gaze across at the mysterious Island of Staten. Mysterious because of the foul odors that drifted across the waters from a place oddly named Fresh Kills, but even more peculiar because it was inhabited by New Yorkers! How could an island that was no more than 1,400 feet away from the foot of Fayette Street not be part of New Jersey? I might have been a curious fellow, but I was not yet so stout of heart to ride my bike over the Outerbridge onto a smelly island inhabited by foreigners. I would have to wait until I was older and drive over to watch the sun rise on Great Kills Beach with a few friends and a few beers.

So why is Staten Island part of New York? If drawing a line from Jersey City to the tip of Sandy Hook, Staten Island would lie fully within what would appear to be the boundaries of New Jersey. The Hudson River channel, a natural boundary, obviously runs through the Narrows and could not be alleged to run through the Kill Van Kull and Arthur Kill. It is only 1,200 feet at the Bayonne Bridge and a mere 672 feet distant at the Goethals

An 1876 Everts and Stewart map of Middlesex County revealing the proximity of Staten Island to the New Jersey shoreline. *Author's collection.*

Bridge. The closest point between Staten Island and the rest of New York is at the Verrazano Bridge, a whopping 4,620 feet away. You can row a boat from Jersey to Staten Island and not even break a sweat, but don't try to cross the Narrows that way! From a geographic, commercial and real estate point of view, it just doesn't make sense.

As early as 1609, Henry Hudson had claimed the area of New York and New Jersey as part of New Netherland for the Dutch. He named *Staaten Eylandt* after the States General of the United Colonies.[148] The island of Manhattan was officially settled in 1624, south of what is today known as Wall Street (because there was an actual wall built there by the Dutch for defensive purposes). By 1641, the Dutch attempted to increase their settlements on Staten Island. Patroonships were granted to Godarde van Reede and Cornelis Melijn on the island, which grew steadily until the Peach Tree War erupted and the Dutch retreated to Manhattan.[149]

The Dutch had many difficulties getting along with the local Lenape tribes. Each time the Dutch attempted to expand out beyond Nieuw Amsterdam, they ran afoul of the locals. The wives of many West India Company employees refused to live on Staten Island for fear of the natives and the

constant wars between the Dutch and the Lenape.[150] There were continued hostilities in New Jersey up until 1660, when the first successful fortified Dutch settlement in New Jersey was established at Bergen. Its boundaries are still evident today in Jersey City in the four square blocks enclosed by Van Reypen, Newkirk, Tuers and Vroom Streets. In 1661, the Dutch returned to Staten Island and established a permanent settlement called Oude Dorp, or Old Town, which was later expanded to include Niew Dorp. Just three years later, the English came to town and claimed EVERYTHING for England.

Now, the legend goes that in 1668, the question of ownership for Staten Island was settled by a boat race. The story, recounted in an 1873 newspaper article (over two hundred years later) and erroneously repeated by Mayor Bloomberg a few years back, said that James, Duke of York, granted all the lands west of the Hudson River to New Jersey with the exception of all the "small" islands in the bay.[151] A small island was supposedly defined as any island that could be circumnavigated in less than twenty-four hours. A stalwart English captain named Christopher Billopp and supposed resident of Staten Island rose to the occasion and got around in a few minutes under twenty-four hours, thus claiming the island for New York!

This is a very romantic yarn, but is utterly unsupported by facts. Captain Billopp did become a resident of Staten Island (his home still stands near Tottenville), but it was not until 1674 that he purchased 932 acres from the Duke of York. He did not achieve the rank of captain in the Royal Navy until 1671. There is no proof that such a race ever took place.

This is the true story. James, Duke of York, received title to all of New York, New Jersey and part of Connecticut by grant from Charles II on March 12, 1664. This grant included not only the title to the land but also the right of governance. It was three months later that the Duke "subdivided" his property and created New Jersey. He gave New Jersey to Berkeley and Carteret, once again with the additional right to govern. The problem begins in the interpretation of the descriptions contained in these two grants. Neither one refers to Staten Island by name or metes and bounds. The only reference in the Duke of York's March 12 grant is: "…together also with the said river called Hudson's River, and all the land from the west side of the Connecticut river to the east side of the Delaware Bay: and also several other islands and lands." This description, although extremely vague, most certainly includes Staten Island. The description in the June 24 subdivision grant to Berkeley and Carteret sets the easterly boundary line for New Jersey as "lying and being westward of Long Island, and Manhitas Island and bounded on the east part by the main sea, and part by Hudson's

Postcard of the Captain Christopher Billopp House on Staten Island, site of the ill-fated 1776 peace conference attended by John Adams, Lord Howe and Benjamin Franklin. *Courtesy of Randall Gabrielan.*

River." No mention of the Kill Van Kull, no mention of the Arthur Kill, no mention of the Narrows, no mention of Staten Island and most certainly no mention of the "small islands." New York would later argue that this meant it had jurisdictional authority right up to the low-water mark of the New Jersey mainland.

This discussion relates to sovereignty and jurisdiction, not land titles. In the colonial period, New Jersey began as a proprietory colony and changed to a royal colony in 1702. New York was always a royal colony by virtue of the Duke of York's ownership and control. Richard Nicolls was the first Englishman to exert political control over New York and New Jersey in 1664, when he arrived to conquer the Dutch. He was unceremoniously and unexpectedly replaced in August 1665 when Philip Carteret, cousin of George Carteret, arrived with a commission and instructions from Berkeley and Carteret.[152] Nicolls was replaced by Francis Lovelace, who would later suffer the misfortune of being "out of town" when the Dutch recaptured New York in 1673. Lovelace would lose all his lands on Staten Island and was detained in the Tower of London. In May 1672, Philip Carteret would be deposed by a popular uprising led by his cousin "President" James Carteret.[153] From 1672 to 1674, New Jersey did not have a resident governor. Philip

Carteret would return in 1674, only to be abducted six years later, arrested and beaten by New York governor Edmund Andros, who believed that he was the rightful governor of New Jersey.[154] In the seventeenth century, it was a very long way from England to the American colonies. This was a period of political and social unrest, and governance was a right to be seized. In the 1680s, East and West Jersey had separate governors. In 1702, the rights of governance were revoked by Queen Anne, and thus began the period of royal governorship. New York and New Jersey would share the same royal governor from 1702 to 1738—much to the detriment of New Jersey.

So one can see how the question of who had sovereignty over the Island of Staten was not a truly significant concern prior to the Revolution. They were too busy just trying to keep their governors' scorecards accurate. It was not until after the Revolution that the former colonies (now states) would start to flex their territorial muscles. Although they had entered into a union, the individual states conducted themselves more as individual nations. You were a New Yorker, a New Englander or a Virginian before you were a citizen of the United States. So, of course, these burgeoning economies were extremely protective of their commercial rights and waged commercial warfare.

That brings us to 1798 and the Hudson River Steamboat franchise. Now, this is where the story gets interesting because of the cast of characters involved. New York granted Robert Livingston, founding father and negotiator of the Louisiana Purchase, and Robert Fulton, the father of the American steamboat movement, the exclusive rights to operate steamboats within the waters of the Hudson River and New York Bay. That would include the Arthur Kill, Kill Van Kull, Raritan Bay, Newark Bay and the entrances to the Passaic and Hackensack Rivers. New Jersey objected, seeing this as an obvious move to establish the right to regulate all navigational commerce along its eastern coast. New Jersey claimed that the boundary line should be down the middle of the river, which would be through the Verrazano Narrows. The two states unsuccessfully attempted to amicably resolve this dispute in 1807.

Meanwhile, both Connecticut and New Jersey reacted harshly to this monopoly. Connecticut passed a law forbidding monopoly vessels from entering its waters, and in New Jersey, the owner of any vessel seized by the monopoly for violations was authorized to return the insult by commandeering any and all monopoly vessels in Jersey waters. Piracy had once again returned to the Jersey coast. Vessels loaded with armed thugs were patrolling the waters, searching for targets of opportunity.

In 1818, Thomas Gibbons hired a young twenty-four-year-old captain by the name of Cornelius Vanderbilt, a native of Staten Island, to run a

The Vanderbilt mausoleum, located in the Moravian Cemetery on Todt Hill atop Staten Island, is the final resting place of Cornelius Vanderbilt. *Courtesy of Randall Gabrielan.*

steamboat ferry service from New Brunswick to Manhattan. Vanderbilt was particularly resourceful and elusive. He was able to avoid seizure by the monopoly vessels time and again. His early experiences and guile on these waters would serve him well in later years in becoming the second-richest man in America, worth more than $143 billion in today's money.

Vanderbilt's success would cause his employer's competitor, Aaron Ogden, a former New Jersey governor and former partner of Gibbons, to file suit against Gibbons, which would result in the landmark Supreme Court decision in *Gibbons v. Ogden, 22 U.S. 1* (1824). The court decided in favor of Gibbons in establishing that, under the Commerce Clause of the U.S. Constitution, only the U.S. Congress had the right to regulate interstate navigation. Unfortunately, the court did not address the specific sovereign boundaries between New York and New Jersey.

Once again, both sides sat down in 1827 to hammer out an agreement, unsuccessfully. So, New Jersey turned to the Supreme Court to resolve the question in *New Jersey v. New York, 28 U.S. (3 Pet.) 461* (1830). However, before

this case was decided, the two states came to an agreement in 1833. The agreement was approved by Congress as the Compact of 1834 and enacted into federal law as Act of June 28, 1834, Ch. 126, 4 Stat. 708. Article I of this compact set the territorial boundaries between New York and New Jersey as follows:

> *The boundary line between the two states of New York and New Jersey, from a point in the middle of Hudson River, opposite the point on the west shore thereof, in the forty-first degree of north latitude, as heretofore ascertained and marked, to the main sea, shall be the middle of the said river, of the Bay of New York, of the waters between Staten Island and New Jersey, and of Raritan Bay, to the main sea; except as hereinafter other-wise particularly mentioned.*

If you go to MapQuest or Google Earth or look at any road map, you will see that only half of the Raritan Bay is in New Jersey and that all of the Narrows is in New York. The proprietors and our forefathers did us no favor in the vague and ambiguous way in which they described lands and boundaries 350 years ago. This would not be the end of boundary controversies in the waters between New Jersey and New York. Under the Compact of 1834, New York retained regulatory and police powers over all the waters right up to New Jersey's low-water line. This would foster a controversy over Ellis Island, which was ultimately decided favorably for New Jersey by the U.S. Supreme Court in 1998 (*New Jersey v. New York 532 U.S. 767*). The court held that the property above the waterline in 1834 was within New York's jurisdiction, but due to New Jersey's complex tidelands law, all the filled land, which represents approximately 80 percent of the current island, was within the jurisdiction of New Jersey. Of course, title ownership to the entire island is vested in the federal government as a national park.

PUBLIC BURIALS ON PRIVATE LANDS: LOST GRAVESTONES IN THE ENGLISH NEIGHBORHOOD

Relatives of people buried in cemeteries on private property have a common law right to access the property to visit the cemetery. That right, which is an implied easement in gross, is recognized by statue in about a fifth of states and by case law in many others.
—*Alfred P. Brophy, Professor of Law, University of Alabama School of Law; JD, Columbia University; PhD, Harvard University*

Little boys can often be found in a sandbox or in their yards digging, moving earth, building castles and generally communing with the land. They diligently burrow into the ground in the hopes of discovering precious gems, gold, buried treasure and, maybe if they try hard enough, a direct route to China! Obstacles will appear—old wires, roots, construction debris or even a rare Indian arrowhead. However, finding an eight-foot- by two-foot tombstone from 1849 buried just under the surface in your yard—well, that might be considered slightly out of the ordinary. But what an amazing and mystifying discovery for a young excavator!

In 1993, on Grand Street in Leonia, such a stone was uncovered and set into motion a chain of events that revealed a history of religious schisms, church abandonment, land development, sacrilege, deceit and litigation. The stone was that of yeoman John Lydecker (1795–1849), buried in the churchyard of the True Reformed Dutch Congregation of the English Neighborhood.[155] It was lying on its back about three inches under the lawn at the very northerly edge of the property. What claim does John Lydecker

have to the plot of land where his body lays? Is there a deed for the land? Certainly, once laid in the ground, one must acquire some land rights. And what of the family, friends and loved ones—do they not have an inherent right to visit their departed ancestors in perpetuity?

The answer to these questions begins in 1768, when the first Reformed Dutch Church was built at the corner of Grand Avenue and Hillside Avenue in an area of Bergen County known as the English Neighborhood, where Dominie Garret Lydecker presided over the congregation. This church would be torn down and relocated to a "more Proper Place" down the road in Ridgefield to a much larger property that could accommodate a large cemetery, where it still stands to this day at 1040 Edgewater Avenue.[156]

Meanwhile, the Dutch Reformed Church in America was experiencing some challenges of faith and ecclesiastical differences, what some referred to as schisms. So, on February 20, 1824, Reverend Cornelius T. Demarest led a group of dissenters from the Dutch Reformed Church in Ridgefield back to the English Neighborhood to establish a new congregation to be called the *True* Dutch Reformed Church. Westervelt's history claims that "a New Meeting House was built" at 304 Grand Avenue.[157]

The True Dutch Reformed Church in the English Neighborhood acquired the land upon which the new church had been built on January 21, 1832, via two separate deeds from Garret and Jane Myer and Jacob and Margaret Cole, respectively.[158] Title was vested in elders Reverend Christian Z. Paulison, Abraham Lydecker and John Edsall and deacons John Cole and Jacob B. Naugle, comprising the consistory of the church. This is a very common manner in which title was held by religious institutions. The consistory held the land as fiduciaries in trust for the congregation.

Twenty years later, on October 12, 1854, the church officially assumed the title of "The Ministers, Elders, and Deacons of the True Dutch Reformed Congregation of the English Neighborhood" by recording a certificate of incorporation in the Bergen County Clerk's Office. Listed as elders were Reverend Cornelius J. Blauvelt, James G. Brinkerhoff and David Morse; deacons were Thomas W. Demarest and Isaac Vandelinda. In just a little over twenty years, the reverend, elders and deacons had completely changed. This might have been a portent of the disharmony that would revisit this congregation in the coming years.

Fast-forward to December 18, 1898, when the majority of the congregants voted to abandon the church building on Grand Avenue and the True Dutch Reformed congregation, withdrawing from the Classis of Hackensack, and submitted their petition to the Presbytery of Jersey City

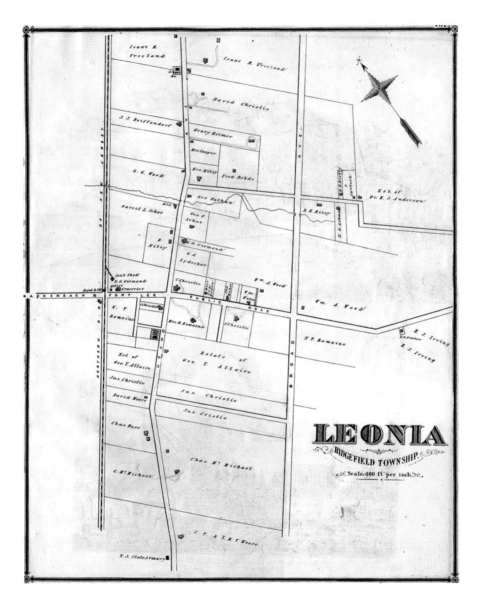

to be organized as a Presbyterian church. Forty-eight members followed Reverend James Wyckoff around the corner to the new Presbyterian Church of Leonia at 181 Fort Lee Road. They left the classis, their religion and the church behind, empty and hollow. Surrounding that church building were the graves of their predecessors and ancestors—forty-six, to be exact. This is known because an old "tombstone hound" by the name of John Neafie visited there on October 3, 1909, and took an inventory

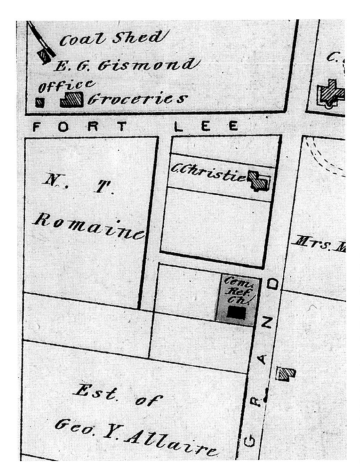

Opposite: An 1876 Walker atlas of Leonia, Ridgefield Township, Bergen County. *Courtesy of the New Jersey State Archives.*

Left: Detail from an 1876 Walker atlas of Bergen County revealing "Cem. Ref. Ch." on Grand Avenue in Leonia. *Courtesy of the New Jersey State Archives.*

of the gravestones.[159] Maybe he knew what the future might hold for these poor souls.

The church sat dormant for the next twenty years when, on July 29, 1919, the True Dutch Reformed congregation of the English Neighborhood, under a deed signed by Samuel I. Vanderbeek, John C. Voorhis and George C. Brinkerhoff, conveyed the church property to the Classis of Hackensack of the True Dutch Reformed Church. Six years later, the Classis of Hackensack conveyed the property to the Eastern Home Mission Board of the Christian Reformed Church. This was a joint ministry between Classis Hackensack and Classis Hudson to sponsor new congregations. It appears they were unsuccessful in rejuvenating this church. Moreover, the property was burdened with onerous restrictions:

...for the purpose of holding meetings for sacred or divine worship social prayer V C and for transacting the temporary concerns of the congregation or church before mentioned and for no other purposes in the Meeting House already erected and built or in any other building which may hereafter be erected by the above mentioned congregation [and] to be used and enjoyed only for church purposes and no other.[160]

The property was destined to remain unused until a new ministry could be found. This was not a practical solution, and in 1929, the Eastern Home Mission Board brought suit to quiet title in order to invalidate the restrictions.[161] After receiving relief from the court, the board immediately sold the property to a land developer, who would then lose it through foreclosure. It would wind up back in the hands of the Eastern Home Mission Board.[162] There was talk of turning it into a theater to house the local Players Guild, but it was found to be unsuitable due to the proximity of the gravestones to the building. Expansion of the structure would have been impossible.[163]

On or about January 28, 1933, it was reported in the newspaper that the Leonia church had been razed as part of a WPA-type project. So now the cemetery stood alone on this ground. This was confirmed in January 1946, when two venerable tombstone hounds, Herbert S. Ackerman and Arthur J. Goff, compiled an inventory of cemeteries chiefly in Bergen County. This effort, known as *Thirty-Seven Cemeteries*, contains a list of the forty-six burials in the Grand Street Cemetery in Leonia. It matches exactly the list compiled by Neafie in 1909. Ackerman and Goff stated definitively, "We have personally copied and checked these cemeteries and also carefully compared them with records taken at earlier dates by others." John Lydecker's tombstone is listed in their inventory, and therefore it can be relied on that in 1946, his stone and forty-five others in the cemetery were upright and aboveground.

In 1954, the cemetery and adjoining land was conveyed to Margery Russell and was no longer burdened by the church or the restrictions on its use. Up until that time, the property appeared on the tax list as Block 26, Lot 11A and was classified as a cemetery.[164] Margery built a house on adjoining Lots 11 and 12. In 1962, the property was purchased by Morris Weiss and no longer classified as a cemetery.[165] In 1963, Lot 11A disappeared from the tax list altogether, having been combined with Lots 11 and 12 for tax purposes. Morris Weiss died in 1968, and the title passed through the several estates and a few different hands, including another quiet title action, before finally landing in possession of Lorant and Marie Louise Schacht on January 12, 1977.[166]

A few months later, the Schachts were shocked to find three gravestones buried three feet underground in their yard while doing excavation for a new fence. The *Union City Dispatch* reported on May 23, 1977, "At present only three tombstones have been uncovered near the chain-link fence. The largest is a heavy granite slab over eight feet long that commemorates the 1841 death of Jane Christie Lydecker at the age of 29. The other tombstones are in memory of Peter T. Demarest (died 1849) and Garrit Lydecker (died 1848)." Jane Christie was John Lydecker's wife, and Garrit was his father. It appears no one had informed the Schachts that their property contained a cemetery. Sometime between 1954 and 1977, every tombstone had been removed or buried. This might be attributed to nature and time, but when compared to other contemporary churches with graveyards, it does not withstand scrutiny.

In the Cheesequake section of Old Bridge Township on Route 34, near its intersection with Cottrell Road, there are two similar cemeteries—one Baptist, the other Methodist—no more than 1,800 feet apart. Both churches were standing in 1876.[167] The Baptist churchyard contains the graves of eighteenth-, nineteenth- and twentieth-century parishioners. The church was torn down around 1930. The Methodist church was built in 1804 and was torn down sometime between 1940 and 1957. Despite time, neglect, vandalism and the ravages of Mother Nature, the tombstones in both cemeteries remain primarily aboveground. Some are worn, others are lying on their backs, some have been assaulted by falling trees and still others have been subject to the mischief of youth. Yet the vast majority stand at attention, keeping silent watch over those entrusted to their care.

Not so in Leonia. The *Bergen Record* reported on June 20, 1977, that Mr. Schacht didn't know the cemetery was there. He said, "I wish I could sell the house and get rid of it."[168] Schacht had also stated, "We should have been notified of this in the original title search." This begs the question: Would a title search have revealed the existence of this cemetery—and what title rights, if any, are vested in the deceased and their heirs? Title searches are historically limited to the public land records. That does not include municipal records, historical records, tax records, newspapers and a long list of alternative research resources. The land records are based on the concept of constructive notice, wherein a document is recorded with the county clerk or register for the specific purpose of placing interested parties on notice of matters that might affect the title to land. Through the process of due diligence, these recordings would be readily revealed.

This differs from actual notice, which is what the Schachts would have had if the tombstones were still aboveground. Then there is implied notice,

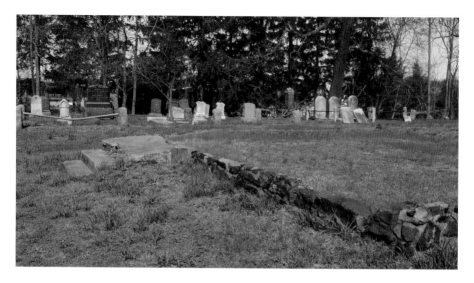

Methodist church and graveyard at Cheesequake in Old Bridge. *Photograph by Heather Paich.*

which occurs when things appear in the public land records that don't specifically identify an adverse condition but supply enough facts when examined together to require further and greater investigation. In this case, there were two maps of Leonia Park filed in the county clerk's office in 1891 that clearly show the "C.R. Church" (Christian Reformed) located on the property but make no reference to a cemetery. The chain of title clearly shows that the property was owned by a religious entity for 122 years but reveals no mention of a cemetery. Should a title searcher do additional research on every property owned by a religious entity in order to ascertain its use as a cemetery? Doubtful. It appears that, in this case, some level of subterfuge was employed to obliterate the remnants of the cemetery so that the land could be developed as a residential lot. Didn't the people in the neighborhood notice that the gravestones had disappeared?

The *Bergen Record* reported that the Leonia Environmental Commission had applied for a grant in the hopes of registering the cemetery "as a federal or state historic landmark." There was even talk of a Columbia University professor being brought in to investigate the site. It appears that none of that ever came to pass. Yes during the next year, many letters were sent from the borough to the cemetery board and to the statehouse and the public advocate. In a letter dated July 6, 1978, to the public advocate, the vice-chairwoman of the Leonia Environmental Commission stated, "I have recently spoken with

Ms. Fields of the Attorney General's Office, and at last we are seeing some action." What kind of action is not evident. On November 21, 1991, fourteen years after uncovering three headstones, the property was sold to Galo P. and Rosario Brito by Lorant Schacht and Marie Louise Schacht.[169] Not too long after, the Britos found a headstone—that of John Lydecker. They claim that they were never informed about the existence of an ancient cemetery buried on the property. The cemetery portion of the property was never acquired by any governmental agency or preserved or dedicated as a historic site, and no one knows where the three headstones found in 1977 are today.

To understand the full import of this story, the following question needs to be answered: Who is John Lydecker, and why do we care? John was born on Christmas Day 1795. He was part of the Dutch community that dominated Bergen County and part of a prominent family of landowners. His family members served in the clergy and, no doubt, he was a very devout man. On February 22, 1840, at the age of forty-five, he married Jane Christie, a twenty-eight-year-old member of another prominent family in the English Neighborhood—the same family who originally donated the land for the church and graveyard. Jane's mother was a Westervelt. This might have been one of the very last happy days of John Lydecker's life, for his beloved wife, Jane, would die the very next year. His brother Abraham died just a few months later, followed by his father, Garrit, in 1848. John's mother, Hannah Westervelt Lydecker, died of "old age" a year later on September 15, 1849. John's tombstone tells his story:

When on that sad and mournful day,
His Mother's corpse was born away,
Grim death commissioned from on high,
Struck at his life—He too must die

But Jesus sends a gracious dart,
To pierce and wound his inmost heart,
In great distress he seeks God's face,
And finds in Christ a heavenly peace

Just nineteen days after his mother passed away, John Lydecker succumbed to "bilious diahrea," from which he had been suffering for three weeks prior. He died on October 4, 1849, at the age of fifty-three.[170] His stone is eight feet tall, two and a half feet wide and was cut and inscribed by J.T. Sinclair of New York. James Sinclair was a Scottish stonecutter and principal of

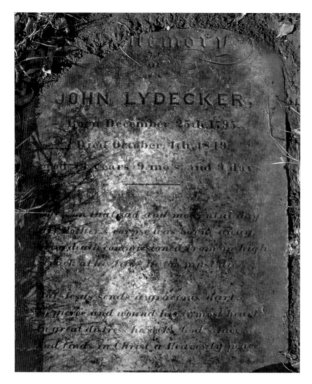

John Lydecker's headstone from the churchyard of the True Reformed Dutch Church of the English Neighborhood, carved by James T. Sinclair. *Photograph by Heather Paich.*

the firm of Masterton, Smith & Sinclair Stone Dressing Co., located at the foot of East Twenty-ninth Street in New York City.[171] James would go on to be a master stonecutter and lay the stones for the Washington Memorial Arch, designed by Stanford White and erected in 1892. He was one of the eight dignitaries who ascended to its top on April 5, 1892, to place the final stone.[172] It is an ironic twist that the Washington Arch was built partly on a Potter's Field. When excavation for the eastern pier was underway, workers found a coffin with human remains and a gravestone dated 1803.[173] John Lydecker's gravestone and, most likely, that of his wife, Jane (now lost forever), were undoubtedly some of the earliest examples of Mr. Sinclair's craft.

This is the story of a yeoman farmer and the circumstances that have obliterated his memory from our historical landscape. New Jersey is woefully behind many other states in the preservation of ancient and historic gravesites. The New Jersey Cemetery Act (NJSA 45:27-1, NJAC 13:44J-1.1) is limited to regulating commercial and religious cemeteries, created and managed by a cemetery company. As such, it cannot be relied on for assistance, as the good people of Leonia found out. The limitations of the so-called Historic Cemetery Act (NJSA 40:10B-1) are exceeded only by its brevity and failure to address the dire plight of so many ancient and historic gravesites. As the years go by, it will require many more intrepid souls willing to take up their historical shovels and dig deeper.

CONCLUSION

We are all connected by and to the land, both physically and existentially. It gives us sustenance and a place to call home. The history of the land and all who have possessed it resides in the various county recording offices (clerks/registers, surrogates and archives) throughout the state. There are literally millions of documents wanting a second look. Each document is a door waiting to be opened—deeds, mortgages, maps, manumissions, two-thousand-year leases and more. Our history is the history of the land. Regardless of wars and disputes, good deeds and bad deeds, the land endures. In the same way that the land itself holds archaeological treasures that offer percipient insight, the land documents contain historic gems of refulgent possibilities.

IMPORTANT DATES IN
NEW JERSEY LAND TITLE HISTORY

June 24, 1497—John Cabot "discovers" North America on behalf of England.

September 3, 1609—Hudson sails up the river that will bear his name.

June 1624—Captain Cornelis Jacobszoon May brings the first settlers to colonize New Netherland (Governors Island and Manhattan).

July 12, 1630—Michael Pauw receives the first Dutch land grant on the west bank of the Hudson River (Jersey City), known as Pavonia.

1641—Pig War

1642—Whiskey War

February 25, 1643—129 Dutch soldiers attack and kill 120 Lenape in what would become known as the Pavonia Massacre.

October 1, 1643—The Lenape respond and drive the Dutch from New Jersey.

1643–45—Kieft's War, aka the First Dutch-Munsee War

1652–54—First Anglo-Dutch War

1654—Stuyvesant grants lands *achter de kol* (meaning "behind or beyond the ridge").

1655—Peach Tree War aka the Second Dutch-Munsee War

1655–57—Second Anglo-Dutch War

January 30, 1658—The peninsula between the Hudson River and the Hackensack River is purchased by the Dutch from the Lenape and named Bergen.

1658–63—Esopus War aka the Third Dutch Munsee War

December 1663—Settlers from Gravesende, Long Island, led by Richard Stout, travel to New Jersey to purchase land from the native inhabitants on what would become known as the Monmouth Patent.

March 12, 1664—Charles II grants all lands between the Connecticut and Delaware Rivers to James, Duke of York.

May 25, 1664—Colonel Richard Nicolls sets sail for Manhattan.

June 24, 1664—James, Duke of York, conveys the colony of New Cesarea to Berkeley and Carteret.

August 19, 1664—Nicolls arrives in Hudson Harbor; Stuyvesant surrenders.

September 8, 1664—Stuyvesant signs the Articles of Capitulation.

September 26, 1664—John Bailey, Daniel and Nathaniel Denton, Thomas Benedick, John Foster and Luke Watson (known as the East Enders) petition to purchase land in New Jersey from the Indians.

October 28, 1664—Mattano conveys a tract of 500,000 acres to John Bailey, Daniel Denton and Luke Watson (Elizabethtown Associates) for £154.

November 24, 1664—The associates land two and half miles up the Elizabeth River and begin to build the first permanent English settlement in New Jersey.

December 1, 1664—Nicolls confirms transfer of the Elizabethtown grant to the associates.

February 10, 1665—Philip Carteret (cousin of George) is named governor of New Jersey and issues the Concessions and Agreements.

April 8, 1665—Nicolls confirms the Monmouth Patent.

August 1, 1665—Governor Philip Carteret arrives in New Jersey at Elizabethtown and purchases a share, becoming an associate.

February 19, 1666—The settlement is named Elizabethtown in honor of the wife of Sir George Carteret.

May 25, 1668—The First New Jersey Assembly meets in Elizabethtown.

March 25, 1670—Carteret demands payment of quit rents, one half penny per acre, per year.

May 14, 1672—Captain James Carteret, son of Sir George Carteret, is elected "president" of New Jersey by an ad hoc assembly and usurps his cousin Philip Carteret's authority.

July 1, 1672—A dejected Philip Carteret returns to England.

July 16, 1672—The Second Dutch War is declared in New Jersey.

July 30, 1673—The Dutch recapture New York and New Jersey.

February 9, 1674—Treaty of Westminster; the English regain New Jersey by "right of conquest"

March 1674—Berkeley sells his half interest in New Jersey to Edward Byllynge and Major John Fenwick for £1000.

June 29, 1674—Charles II reconfirms his grant to the Duke of York.

July 28, 1674—The Duke of York reconfirms his grant to Carteret only.

November 1674—Governor Philip Carteret returns to New Jersey with a letter from Carteret nullifying the Nicolls grants.

July 1, 1676—A quintipartite (five parties) deed/agreement is signed by George Carteret, William Penn, Edward Byllynge, Gawen Laurie and Nicholas Lucas.

January 14, 1680—George Carteret dies.

April 1680—New York governor Edmund Andros kidnaps and beats Philip Carteret while arresting him for trial in New York. The New York jury acquits Carteret, but he agrees not to resume his position as governor of New Jersey.

1682—East Jersey is sold at auction for £3400 to twelve proprietors led by William Penn.

December 1682—At forty-four, Philip Carteret dies in Elizabethtown from injuries inflicted by Andros and his men.

1695—*Fullerton v. Jones*; proprietory court ruled against Jones (associate) (king and council reversed on appeal)

April 15, 1702—Proprietors surrender rights of government.

December 5, 1702—Edward Hyde, Lord Cornbury, was named royal governor of New York and New Jersey

April 17, 1745—Elizabethtown bill in chancery is filed by James Alexander.

September 20, 1745—Newark "Horseneckers" storm the jail and free squatter Samuel Baldwin.

January 17, 1746—A Newark mob confronts the sheriff and the militia and storms the jail again to free fellow rioters.

August 5, 1746—Magdalena Valleau and an armed mob of forty drive Edward Jeffers out of his home and off his land in the disputed Ramapo Tract.

July 17, 1747—Two hundred fully armed rioters led by Amos Roberts, "King of the Rioters," march on Perth Amboy and attack the jail.

February 17, 1748—The New Jersey Assembly approves an act of pardon for the rioters.

August 1751—The Elizabethtown Associates file answer to Bill (never judicially settled).

1755—Abraham Clark, future signer of the Declaration of Independence, leads a group of Elizabethtown men in a fight to reclaim Morgan's Mine on the Middlesex-Somerset border, asserting ownership by virtue of the Nicolls grant.

September 1, 1773—By royal edict, King George approves and sets the northern boundary of New Jersey.

July 2, 1776—New Jersey's First Constitution

July 4, 1776—Declaration of Independence

June 28, 1834—New York and New Jersey agree that Staten Island belongs to New York.

GLOSSARY OF LAND TITLE TERMS

abstract of title (also known as a title search): A summary of the public records relating to the title to a particular piece of land. A title insurance company reviews an abstract of title to determine whether there are any title defects, which must be cleared before a buyer can purchase clear, marketable and insurable title.

acknowledgment: A formal declaration before a duly authorized officer (such as a notary public) by a person who has executed an instrument that such execution is his own act and deed. An acknowledgment is necessary to entitle an instrument to be recorded, to impart constructive notice of its contents and to entitle the instrument to be used as evidence without further proof. The certificate of acknowledgment is attached to the instrument or incorporated therein.

administrator: A person appointed by the probate court to carry out the administration of a decedent's estate when the decedent has left no will. If a woman is appointed, she is called an administratrix.

assignment for the benefit of creditors: An early form of bankruptcy procedure under state law.

bankruptcy: A special proceeding under federal or, in some instances, state laws by which the property of a debtor is protected by the court and may be divided among the debtor's creditors and the debtor.

bona fide purchaser: One who buys property in good faith, for fair value, and without notice of any adverse claim or right of third parties.

Gunter's chain: Developed by English mathematician Edmund Gunter in 1620 as an instrument to measure land. A chain is 66 feet long and has one hundred links, each link being 7.92 inches. The chain is based on the length of four rods or perches (16.5 feet).

chain of title: The successive ownerships or transfers in the history of title to a tract of land.

conveyance: An instrument by which title is transferred; a deed. Also, the act of transferring title.

deed: A formal written instrument by which title to real property is transferred from one owner to another. The deed should contain an accurate description of the property being conveyed, should be signed and witnessed according to the laws of the State where the property is located, and should be delivered to the purchaser at closing day. There are two parties to a deed: the grantor and the grantee.

description: The exact location of a piece of real property stated in terms of lot, block, tract, part lot, metes and bounds, recorded instruments, or U.S. government survey (sectionalized). This is also referred to as legal description of property.

devise: A disposition of property made by a will.

documentary stamps: A state tax (federal tax prior to 1968) in the forms of stamps and required on deeds and mortgages when real estate title passes from one owner to another. The amount of stamps required varies with each state.

egress: The right to leave a tract of land; usually used as part of the term "ingress and egress" and interchangeably with "access."

eminent domain: The right of a government to take privately owned property for public purposes under condemnation proceedings upon payment of its reasonable value.

encumbrance : A legal right or interest in land that affects a good or clear title and diminishes the land's value.

escheat: The reversion of property to the state when an owner dies leaving no legal heirs, devisees or claimants.

estate: (1) The interest or nature of the interest which one has in property, such as a life estate, the estate of a decedent, real estate, etc. (2) A large house with substantial grounds surrounding it, giving the connotation of belonging to a wealthy person.

examination of title: The investigation and interpretation of the record title to real property based on the title search or abstract.

execute: To sign a legal instrument; a deed is said to be executed when it is signed, sealed, witnessed and delivered.

executor: A person appointed in a will and affirmed by the probate court to cause a distribution of the decedent's estate in accordance with the will. (The one who makes the will is called a "testator.") If a woman is appointed, she is referred to as the "executrix."

fee simple: An estate under which the owner is entitled to unrestricted powers to dispose of the property and which can be left by will or inherited; commonly used as a synonym for ownership.

foreclosure: A proceeding in or out of court that extinguishes all rights, title and interest of the owner(s) of property in order to sell the property to satisfy a lien against it.

forfeiture of title: A common penalty for the violation of conditions or restrictions imposed by the seller upon the buyer in a deed or other proper document. For example, a deed may be granted on the condition that if liquor is sold on the land, the title to the land will be forfeited (that is, lost) by the buyer (or some later owner) and will revert to the seller.

four corners: A title searching term that signifies the process of examining the entire document from beginning to end, including such information that might be contained in the margins and buried within the legal boilerplate.

grantee: The party in the deed who is the buyer or recipient.

grantor: The party in the deed who is the seller or giver.

index: An alphabetical listing in the public records of the names of parties to recorded real estate instruments together with the book and page number of the record.

instrument: Any writing having legal form and significance, such as a deed, mortgage, will or lease.

intestate: Without leaving a will, or leaving an invalid will so that the property of the estate passes according to the laws of succession rather than by direction of the deceased.

judgment: The determination of a court regarding the rights of parties in an action. Money judgments, when recorded, become a lien on the real property of the party whom the judgment is against.

lease: An agreement by which an owner of real property (lessor) gives the right of possession to another (lessee) for a specified period of time (term) and for a specified consideration (rent).

lessee: A party to whom a lease (the right to possession) is given in return for a consideration (rent).

lessor: A landlord; one who gives a leasehold to a lessee.

lien: A claim by one person on the property of another as security for money owed. Such claims may include obligations not met or satisfied, judgments, unpaid taxes, materials or labor.

link: In surveying, a length of 7.92 inches.

lis pendens: A legal notice recorded to show pending litigation relating to real property and giving notice that anyone acquiring an interest in said property subsequent to the date of the notice may be bound by the outcome of the litigation.

livery of seisin: A public ritual before witnesses in which the seller would stand on the ground to be conveyed, picking up sticks, dirt and rocks from that land and placing them in the hands of the buyer while proclaiming the boundaries of the property, along with the terms of payment and the affirmative act of conveyancing.

metes and bounds: A land description in which boundaries are described by courses, directions, distances and monuments.

monument of survey: Visible marks or indications left on natural or other objects indicating the lines and boundaries of a survey. May be posts, pillars, stones, cairns and other such objects. May also be fixed natural objects, blazed trees, roads and even a watercourse.

mortgage: A lien or claim against real property given by the buyer to the lender as security for money borrowed.

mortgagee: The lender in a mortgage agreement.

mortgagor: The borrower in a mortgage agreement.

muniments of title: Written evidence (documents) that an owner possesses to prove his or her title to property.

ownership: The right to possess and use property to the exclusion of others.

perch: See "rod."

personal property: Any property that is not designated by law as real property (e.g., money, goods, evidences of debt, rights of action, furniture, automobiles).

priority: The order of preference, rank or position of the various liens and encumbrances affecting the title to a particular parcel of land. Usually, the date and time of recording determine the relative priority between documents.

public records: The records of all land title documents, which are necessary to give notice and are available to the public.

quiet title: To free the title to a piece of land from the claims of other persons by means of a court action called a "quiet title" action. The court decree obtained is a "quiet title" decree.

quitclaim deed: A deed that transfers whatever interest the maker of the deed might have in the particular parcel of land. A quitclaim deed is often given to clear the title when the grantor's interest in a property is questionable. By accepting such a deed, the buyer assumes all the risks. Such a deed makes no warranties as to the title but simply transfers to the buyer whatever interest the grantor has.

real estate (also called "real property"): (1) Land and anything permanently affixed to the land, such as building, fences and those things attached to the buildings, such as light fixtures, plumbing and heating fixtures, or other such items that would be personal property if not attached. (2) May refer to rights in real property as well as the property itself.

recording vs. filing: Filed documents are the original documents kept by the Recording Officer to impart constructive notice, while recorded documents are copies of the originals presented to the recording officer for recording. The copy is kept on record for eternity, and then the originals are copied then returned. They also impart constructive notice.

rod (aka perch): An old English system of measurement prior to feet and inches; the base measurement for Gunter's chain.

subdivision: An area of land laid out and divided into lots, blocks and building sites and in which public facilities are laid out, such as streets, alleys, parks and easements for public utilities.

survey: A map or plat made by a licensed surveyor showing the results of measuring the land with its elevations, improvements, boundaries and its relationship to surrounding tracts of land. A survey is often required by the lender to assure him that a building is actually sited on the land according to its legal description.

take-back mortgage: A mortgage wherein a seller "takes back" a note and mortgage for a portion of the purchase price, leaving the remainder to be paid in cash.

testate: Leaving a legally valid will at death; see "intestate."

testator: A man who makes or has made a testament or will.

testatrix: A woman who makes or has made a testament or will.

title: As generally used, the rights of ownership and possession of particular property. In real estate usage, title may refer to the instruments or documents by which a right of ownership is established (title documents) or the ownership interest one has in the real estate.

title defect: (1) Any possible or patent claim or right outstanding in a chain of title that is adverse to the claim of ownership. (2) Any material irregularity in the execution or effect of an instrument in the chain of title.

vested: Present ownership rights, absolute and fixed.

will: A written expression of the desire of a person as to the disposition of that person's property after death; must follow certain procedures to be valid.

NOTES

Chapter 1

1. Wacker, *Land and People*, 19.
2. Ibid., 21.
3. McCormick, *Colony to State*, 2.
4. Shorto, *Island at the Center of the World*, 76.
5. Jacobs, *New Netherland*, 70.
6. Kraft, *Lenape-Delaware Indian Heritage*, 415.
7. Map of Bergen, D. Stanton Hammond, J.D.
8. Smith, *Nova-Caesaria*, 36–46.
9. Ibid., 43.
10. Blackstone, *Laws of England*, 48.
11. Ibid., 78.
12. Fineberg, *Handbook*, 1–2, §102.
13. Ibid., §103.
14. Blackstone, *Laws of England*, 314.
15. Bird, *Town of Malmesbury*, 146.
16. Fineberg, *Handbook*, 1–4, §106.
17. The process of lease and release is just one of many forms of conveyance under English law. For more, see Blackstone, *Laws of England*, 339.
18. Hutton, *Charles II*, 43.
19. Ibid., 143.

20. Ibid., 242.
21. Ibid., 218.
22. Leaming and Spicer, *Grants, Concessions, and Original Constitutions*, 8.
23. Hatfield, *History of Elizabeth*, 47.
24. Ibid., 33.
25. Ibid.
26. Thayer, *As We Were*, 15.
27. Hatfield, *History of Elizabeth*, 34.
28. Thayer, *As We Were*, 8.
29. Hatfield, *History of Elizabeth*, 32.
30. Thayer, *As We Were*, 8.
31. Ellis, *History of Monmouth County*, 59–61.
32. Ibid.
33. Ibid., 62.
34. Map of Bergen, D. Stanton Hammond, J.D.
35. Hatfield, *History of Elizabeth*, 51.

Chapter 2

36. As previously discussed, a deed of indenture is a particular form of ancient deed in which the document is drawn twice on the same large piece of parchment—on top and then exactly repeated underneath. Once it is signed and sealed, the two halves are indented or cut apart using a unique and wavy incision that allows the holders of each part to rejoin the two halves to prove the veracity of title.

Chapter 3

37. Veit, *Digging New Jersey's Past*, 11.
38. Wacker, *Land and People*, 58.
39. Blackstone, *Laws of England*, 3.
40. Thayer, *As We Were*, 8.
41. New Jersey Historical Society, *Proceedings*, 317–18.
42. Franklin, *Autobiography*, 57.
43. Monmouth County Clerk (hereafter MCC) Deed Book B, 16.

44. However, 327 years later, a creek bearing his name can still be found in Middlesex County just over the Monmouth County line. Beginning near the intersection of Marlboro Road and East Greystone Road, it runs northwest and empties into Duhernal Lake, shown on Sheet 19.13 of the Old Bridge Tax Map as Iresick Creek. Interestingly, this specific area along the creek has been the subject of considerable title disputes regarding colonial surveying errors. The current tax map still reveals the gaps and overlaps caused by deficiencies of early wilderness land surveying.
45. MCC Deed Book C, 182, 184.
46. Leaming and Spicer, *Grants, Concessions, and Original Constitutions*, 172.
47. Wacker, *Land and People*, 132.
48. Smith, *Nova-Caesaria*, 470.
49. Ibid., 474.
50. Flemming, *Brotherton*, 43.
51. *Unalachtigo Band v. Corzine 606 F. 3d 126* (2010).
52. Act of March 3, 1799, Pub. L. No. 5-46, § 12, 1 Stat. 743, 746.

Chapter 4

53. Leaming and Spicer, *Grants, Concessions, and Original Constitutions*, 24.
54. In 1998, the East Jersey Board of Proprietors quitclaimed all its remaining interest in the unappropriated lands in New Jersey to the State of New Jersey. That transaction included the transfer of all proprietory records to the New Jersey State Archives. In 2005, the West Jersey Board placed its records with the state archives in trust for the better maintenance, cataloguing and access to these private records, which consist of grants, patents, returns, surveys and certificates. However, the West Jersey Board continues to retain its title rights originally acquired from John Berkeley.
55. Leaming and Spicer, *Grants, Concessions, and Original Constitutions*, 399.
56. Ibid.
57. Ibid., 162.
58. Ibid,. 369.
59. Fineberg, *Handbook*, 7–4, §702A.
60. MCC Ancient Deed Book 1, 5.

61. New Jersey Archives 2: 160.
62. Ibid., 388.
63. Ibid., 301.
64. Ibid., 306.
65. Ibid., 301.
66. Ibid., 313.
67. New Jersey Session Laws, Ninth Assembly, 1784, 133.
68. Ibid.

Chapter 5

69. Leaming and Spicer, *Grants, Concessions, and Original Constitutions*, 21.
70. Hodges, *Root and Branch*, 12.
71. U.S. Declaration of Independence.
72. Leaming and Spicer, *Grants, Concessions, and Original Constitutions*, 640.
73. New Jersey Archives 2: 28–20.
74. New Jersey Archives 3: 473–74.
75. Fee simple is the most absolute title that can be possessed and is often referred to as "fee simple absolute." It provides the owner with complete and unlimited control over the real property. It is a freehold estate.
76. Fee tail is also a freehold estate but passes automatically to the estate holder's heirs, thus limiting that person's control over the property.
77. Fineberg, *Handbook*, 2, §202.
78. In 1769, this section was amended to require only one surety and removed the obligation to pay the ex-slave twenty pounds yearly.
79. Soderlund, *Quakers and Slavery*, 118.
80. Monmouth County Surrogate Inventory Book A-1, 226–29.

Chapter 6

81. Soderlund, *Quakers and Slavery*, 177.
82. Ibid., 118.
83. Ibid., 119.
84. Ibid., 29.
85. Ibid., 124.

86. http://www.westjersey.org/ssn.htm#two.

87. Ibid.

88. Wacker, *Land and People*, 416.

89. MCC Deed Book G-3, 244.

90. MCC Deed Book F-4, 133.

91. MCC Deed Book I-3, 206, 208.

92. MCC Deed Book P-3, 303.

93. MCC Deed Book 160, 306.

94. *Asbury Park Press*, July 20, 1998, D1.

95. The author was engaged to provide land record research to the court.

96. Monmouth County Manumission Book D, 2.

97. MCC Deed Book F-4, 133.

98. MCC Deed Book K-6, 36.

99. MCC Deed Book L-6, 302.

100. MCC Deed Book 191, 467.

101. MCC Deed Book 203, 274, 255, 472.

102. MCC Deed Book 739, 210.

103. *Asbury Park Press*, November 30, 1992, A7.

Chapter 7

104. MCC Mortgage Book D, 206 (5/22/1801) and 210 (5/29/1801).

105. MCC Miscellaneous Book B, 62.

106. An Act Respecting Slaves, 1798, Laws of the State of New Jersey 1703–1820, 374.

107. *Gibbons v. Morse 7 N.J.L. 253* (1821).

108. Hodges, *Root and Branch*, 130.

109. An Act Respecting Slaves 1798, Laws of the State of New Jersey 1703–1820, 369.

110. See Glossary.

111. MCC Miscellaneous Book B, 147.

112. Monmouth County Surrogate's Office Inventory Book D, 535.

113. MCC Deed Book W-4, 180.

114. Monmouth County Archives.

115. MCC Mortgage Book A-2, 476.

Chapter 8

116. Lengel, *This Glorious Struggle*, 184.
117. NY Colonial MSS Vol 6, p. 347.
118. Weslager, *Swedes and Dutch at New Castle*, 82.
119. Hudson County Register's Office, Transcribed Deeds Book 1, 184.
120. http://www.nj.gov/state/archives/guides/sdea1006.pdf.
121. Gerlach, *New Jersey in the Revolution*, 259.
122. Fleming, *New Jersey*, 326.
123. http://www.stevens.edu/sit/about/sit.cfm.

Chapter 9

124. Lengel, *This Glorious Struggle*, 195.
125. Adelberg, *American Revolution in Monmouth County*, 10.
126. MCCO Deed Book H, 336.
127. New Jersey State Archives, Minutes of the Court of Oyer and Terminer, Box 5, August 2, 1779.
128. Ibid., August 19, 1779.
129. Smith, *Reliquary*, 223.
130. Colonial Conveyances Book H-3, 223.
131. MCC Deed Book I, 411; MCC Deed Book O, 21.
132. Middlesex County Surrogate Will Books B, 629; ibid., C, 141.

Chapter 11

133. 1850 U.S. Census Mortality Schedule, Third Ward, Trenton, New Jersey.
134. Mercer County Clerk's Office Deed Book 82, 491.
135. Mercer County Clerk's Office Special Deed Book B, 465.

Chapter 12

136. William Ernest Henley (1849–1903), "Invictus."
137. Passaic County Register Deed Book L-2, 478.
138. Ibid., Mortgage Book K-216.
139. Alaya, *Silk and Sandstone*, 1.
140. Ayala, *Silk and Sandstone*, 6.
141. Passaic County Register Mortgage Book X-9, 444.
142. Ayala, *Silk and Sandstone*, 20.
143. Ibid., 22.

Chapter 13

144. Nelson, *Benedict Arnold's Navy*, 43.
145. See Glossary.
146. Leaming and Spicer, *Grants, Concessions, and Original Constitutions*, 4.

Chapter 14

147. Stellhorn and Birkner, *Governors of New Jersey*, 75.
148. Shorto, *Island at the Center of the World*, 49.
149. Jacobs, *New Netherland*, 73.
150. Ibid., 53.
151. *New York Times*, February 21, 2007.
152. Leaming and Spicer, *Grants, Concessions, and Original Constitutions*, 26 & 28.
153. Stellhorn and Birkner, *Governors of New Jersey*, 16.
154. Ibid., 20.

Chapter 15

155. Certificate of Incorporation, Bergen County Clerk's Office.
156. Historic placard at Ridgefield Reformed Church.

157. Westervelt, *History of Bergen County*.

158. Bergen County Clerk's Office (hereafter BCCO) Deed Book 1026, 162, 164.

159. http://files.usgwarchives.net/nj/bergen/cemeteries/chrisref.txt. "Tombstone hound" was a colloquial term used by genealogists in referencing those curious individuals who like to roam about cemeteries and document their visits, of which the author counts himself a member.

160. BCCO Deed Book 1026, 162–65.

161. BCCO Deed Book 1674, 12.

162. BCCO Deed Book 1887, 441.

163. Karels, *Leonia Legacies*, 77.

164. BCCO Deed Book 3587, 56.

165. BCCO Deed Book 4386, 315.

166. BCCO Deed Book 6203, 121.

167. Everts and Stewarts's 1876 atlas of Madison Township.

168. A reprint of this article would appear again in the *South Jersey Press*, June 22, 1977.

169. BCCO Deed Book 7483, 75.

170 National Archives and Records Administration, Non-population Census Schedules for New Jersey, 1850–1880: Mortality; Archive Collection: M1810; Archive Roll Number: 1; Census Year: 1849; Census Place: Hackensack, Bergen, New Jersey; Page: 13.

171. Trow's 1859 New York City Directory.

172. *New York Times*, April 6, 1892.

173. Geismar, "Washington Square Park," 24.

BIBLIOGRAPHY

Adelberg, Michael S. *The American Revolution in Monmouth County: The Theatre of Spoil and Destruction*. Charleston, SC: The History Press, 2010.

———. *The Razing of Tinton Falls: Voices from the American Revolution*. Charleston, SC: The History Press, 2012.

Alaya, Flavia. *Silk and Sandstone: The Story of Catholina Lambert and His Castle*. Paterson, NJ: Passaic County Historical Society, 1984.

Ayler, G.E. *Rebellion or Revolution? England, 1640–1660*. Oxford, UK: Oxford University Press, 1986.

Bassett, William B. *Historic American Buildings Survey of New Jersey: Catalog of the Measured Drawings, Photographs and Written Documents in the Survey.* Newark: New Jersey Historical Society, 1977.

Bird, James T. *The History of the Town of Malmesbury and of Its Ancient Abbey*. N.p.: Market Cross, 1876.

Blackstone, William, Esq. *Commentaries on the Laws of England*. vol. 2. N.p.: Legal Classics Library, 1983.

Bush, Bernard, comp. *Laws of the Royal Colony of New Jersey, 1703*-1745. vol. 2. Trenton: New Jersey State Library Archives and History Bureau, 1977.

Craven, Wesley Frank. *New Jersey and the English Colonization of North America*. New York: D. Van Nostrand Company, 1964.

Cribib, William. *Changes in the Land: Indians, Colonists, and the Ecology of New England*. New York: Hill and Wang, 2003.

Cunningham, John T. *The East of Jersey: A History of the General Board of Proprietors of the Eastern Division of New Jersey*. Newark: New Jersey Historical Society, 1992.

Davis, John David, comp. *West Jersey, New Jersey, Deed Records, 1676–1721*. Berwyn Heights, MD: Heritage Books, 2005.

Ellis, Franklin. *History of Monmouth County, New Jersey*. Philadelphia: R.T. Peck & Company, 1885. Reprinted by the Shrewsbury Historical Society, 1974.

Fineberg, Lawrence Joel. *Handbook of New Jersey Title Practice*. Madison: New Jersey Land Title Institute, 1992.

Fiske, John. *The Dutch and Quaker Colonies in America*. 2 vols. Boston: Riverside Press, 1903.

Fleming, Thomas. *New Jersey, A History*. New York: W.W. Norton & Company, 1984.

Flemming, George D. *Brotherton: New Jersey's First and Only Indian Reservation and the Communities of Shamong and Tabernacle That Followed*. Medford, NJ: Plexus Publishing.

Franklin, Benjamin. *The Autobiography of Benjamin Franklin: 1706–1757*. N.p.: Floating Press, 2009.

Franklin, John Hope, and Alfred A. Moss Jr. *From Slavery to Freedom: A History of African Americans*. New York: Alfred A. Knopf, 2003.

Gabrielan, Randall. *Images of America: Fair Haven*. Charleston, SC: Arcadia Publishing, 1997.

———. *Images of America: Shrewsbury*. Charleston SC: Arcadia Publishing, 1996.

Geismar, Joan H. "Washington Square Park: Phase 1A Archaeological Assessment." New York: New York City Department of Parks and Recreation, August 2005.

Gerlach. Larry R., ed. *New Jersey in the American Revolution, 1763–1783: A Documentary History*. Trenton: New Jersey Historical Commission, 1975.

Green, Howard L., ed. *Words That Make New Jersey History: A Primary Source Reader*. New Brunswick, NJ: Rutgers University Press, 1994.

Goldberg, David J. *A Tale of Three Cities: Labor Organization and Protest in Paterson, Passaic and Lawrence, 1916–1921*. New Brunswick, NJ: Rutgers University Press, 1989.

Hamilton, Alexander, James Madison and John Jay. *The Federalist Papers*. New York: Signet Classics, 2003.

Hartlaub, Robert J., and George J. Miller, comps. *Colonial Conveyances in the Province of New Jersey, 1664–1794*. General Board of Proprietors of the Eastern Division of the State of New Jersey, 1974.

Hatfield, Edwin Francis. *History of Elizabeth, New Jersey*. Carlisle, MA: Applewood Books, 2013. Originally published by Carlton and Lanahan, 1868.

Hodges, Graham Russell. *Root and Branch: African Americans in New York and East Jersey, 1613–1863*. Chapel Hill: University of North Carolina Press, 1999.

———. *Slavery and Freedom in the Rural North: African Americans in Monmouth County, New Jersey, 1665–1865*. Lanham, MD: Rowman and Littlefield, 1997.

Hood, John. *Index of Colonial and State Laws Between the Years 1663 and 1877 Inclusive*. Trenton, NJ: John L Murphy, printer, 1877.

Hunter, Douglas. *Half Moon: Henry Hudson and the Voyage That Redrew the Map of the New World*. New York: Bloomsbury Press, 2009.

Hutton, Ronald. *Charles II: King of England, Scotland and Ireland*. Oxford, UK: Clarendon Press, 1989.

Jacobs, Jaap. *The Colony of New Netherland: A Dutch Settlement in Seventeenth-Century America*. Ithaca, NY: Cornell University Press, 2009.

Karels, Carol. *Images of America: Leonia*. Charleston, SC: Arcadia Publishing, 2002.

———. *Leonia Legacies: Voices Then, Voices Now*. Hackensack, NJ: Tech Repro, 1994.

Klett, Joseph R. *Using the Records of the East and West Jersey Proprietors*. Trenton: New Jersey State Archives, 2008.

Kraft, Herbert C. *The Lenape-Delaware Indian Heritage, 10,000 BC–AD 2000*. N.p.: Lenape Books, 2001.

Leaming, Aaron, and Jacob Spicer. *The Grants, Concessions, and Original Constitutions of the Province of New Jersey*. Plainfield, NJ: Honeyman & Company, 1881.

Lengel, Edward G. *This Glorious Struggle: George Washington's Revolutionary War Letters*. New York: HarperCollins, 2007.

Lurie, Maxine N., and Peter O. Wacker, eds. *Mapping New Jersey: An Evolving Landscape*. New Brunswick, NJ: Rivergate Books, 2009.

Lurie, Maxine N., and Richard Veit, eds. *New Jersey: A History of the Garden State*. New Brunswick, NJ: Rutgers University Press, 2012.

McConville, Brendan. *These Daring Disturbers of the Public Peace: The Struggle for Property and Power in Early New Jersey*. Philadelphia: University of Pennsylvania Press, 2003.

McCormick, Richard P. *New Jersey from Colony to State, 1609–1789*. vol. 1. New York: D. Van Nostrand Company, 1964.

Morris, Ellen Thorne, comp. *Manumission Book of Monmouth County, New Jersey, 1791–1844*. Freehold, NJ: Office of the Monmouth County Clerk, 1992.

Nelson, James L. *Benedict Arnold's Navy: The Ragtag Fleet That Lost the Battle of Lake Champlain but Won the American Revolution*. New York: McGraw Hill, 2006.

New Jersey Historical Society. *Proceedings of the New Jersey Historical Society, 1914*. vol. 9. London: Forgotten Books, 1914.

Ricord, Frederick W., and William Nelson, eds. *Documents Relating to the Colonial History of the State of New Jersey, Volume XV, Journal of the Governor and Council, Vol. III 1938–1748*. Trenton, NJ: John L. Murphy Publishing Co., 1891.

Royster, Charles. *Light-Horse Harry Lee and the Legacy of the American Revolution*. Baton Rouge: Louisiana State University Press, 1994.

Rumson Improvement Association. *History of Rumson, New Jersey, 1665–1965*. Rumson, NJ: Rumson Improvement Association, 1965.

Ryan, Dennis P. *New Jersey in the American Revolution, 1976–1783: A Chronology*. Trenton: New Jersey Historical Commission, 1974.

Sarapin, Janice Kohl. *Old Burial Grounds of New Jersey: A Guide*. New Brunswick, NJ: Rutgers University Press, 1994.

Scranton, Philip B., ed. *Silk City: Studies on the Paterson Silk Industry, 1860–1940*. Newark: New Jersey Historical Society, 1985.

Shorto, Russell. *The Island at the Center of the World: The Epic Story of Dutch Manhattan and the Forgotten Colony That Shaped America*. New York: Vintage Books, 2005.

Skemer, Don C., and Robert C. Morris, comps. *Guide to the Manuscript Collections of the New Jersey Historical Society*. Newark: New Jersey Historical Society, 1979.

Smith, Samuel. *The History of the Colony of Nova-Caesaria, or New-Jersey*. N.p.: Reprint Company, 1966.

Soderlund, Jean R. *Quakers and Slavery: A Divided Spirit.* Princeton, NJ: Princeton University Press, 1988.

Stellhorn, Paul A., and Michael J. Birkner, eds. *The Governors of New Jersey, 1664–1974.* Trenton: New Jersey Historical Commission, 1982.

Still, Dr. James. *Early Recollections and Life of Dr. James Still, 1812–1885.* New Brunswick, NJ: Rutgers University Press, 1973.

Stillwell, John E. *The Old Middletown Town Book, 1667 to 1700; The Records of Quaker Marriages at Shrewsbury, 1667 to 1731; The Burying Grounds of Old Monmouth.*

Swindler, William F. *Chronology and Documentary Handbook of the State of New Jersey.* New York: Oceana Publications, 1978.

Symonds, Craig L. *A Battlefield Atlas of the American Revolution.* Mount Pleasant, SC: Nautical & Aviation Publishing Company of America, 1986.

Tantillo, L.F. *The Edge of New Netherland.* Albany, NY: New Netherland Institute, n.d.

Thayer, Theodore. *As We Were: The Story of Old Elizabethtown.* Elizabeth, NJ: Grassmann Publishing Company, 1964.

Van Der Donk, Adriaen. *A Description of New Netherland.* Lincoln: University of Nebraska Press, 2008.

Van Doren Honeyman, A., ed. *Documents Relating to the Colonial History of the State of New Jersey, First Series, Vol. XXXIII, Calendar of New Jersey Wills, Administrations, Etc., Volume IV, 1761–1770.* Berwyn Heights, MD: Willow Bend Books, n.d.

Veit, Richard F. *Digging New Jersey's Past: Historical Archaeology in the Garden State.* New Brunswick, NJ: Rutgers University Press, 2002.

Veit, Richard F., and Mark Nonestied. *New Jersey Cemeteries and Tombstones: History in the Landscape.* New Brunswick, NJ: Rutgers University Press, 2008.

Wacker, Peter O. *Land and People: A Cultural Geography of Preindustrial New Jersey: Origins and Settlement Patterns*. New Brunswick, NJ: Rutgers University Press, 1975.

Wallace, Anthony F.C. *King of the Delawares: Teedyuscung, 1700–1763*. Syracuse, NY: Syracuse University Press, 1990.

Weslager C.A. *The Swedes and Dutch at New Castle*. Moorestown, NJ: Middle Atlantic Press, 1987.

Westervelt, Frances A., ed. *History of Bergen County, New Jersey, 1630–1923*. New York: Lewis Historical Publishing Company, 1923.

Whitehead, William A. *The Eastern Boundary of New Jersey: A Review of the Hon. John Cochrane's Paper on the Waters of New Jersey*. Newark, NJ: Daily Advertiser Office, 1866.

Winfield, Charles H. *History of the Land Titles in Hudson County, NJ, 1609–1871*. New York: Wynkopp & Hallenbeck, 1872.

Wright, Giles R. *Afro-Americans in New Jersey: A Short History*. Trenton: New Jersey Historical Commission, 1988.

Zilversmit, Arthur. *The First Emancipation: The Abolition of Slavery in the North*. Chicago: University of Chicago Press, 1967.

INDEX

ABOUT THE AUTHOR

Joe Grabas is a nationally certified land title professional who has spent over three decades researching real property records in New Jersey. He is widely recognized as the leading land title educator in the state and formerly served as the president of the New Jersey Land Title Association. He founded the Grabas Institute for Continuing Education to bring alternative, historically based continuing education to the title, legal, real estate and insurance professions and to establish an organization that would support and sustain research into the impact of landownership and conveyancing on the social and economic development of the state of New Jersey. Mr. Grabas serves on the Monmouth County Historical Commission and the New Jersey Tidelands Resource Council. He has been accepted as an expert in matters regarding land titles by the Superior Court of New Jersey and lectures widely throughout the metropolitan area. Joe lives in Freehold, New Jersey, where he supports and remains active in the local history community.